# The Art of
# WHISKY

# THE ART OF
# WHISKY

## THE VANISHING SPIRITS
## OF SINGLE MALT SCOTCH

PHOTOGRAPHS BY ERNIE BUTTON

TEXT BY CHARLES MACLEAN AND HOWARD A. STONE

CHRONICLE BOOKS

SAN FRANCISCO

Library of Congress Cataloging-in-Publication Data available.

ISBN 978-1-7972-1382-8

Manufactured in China.

All photographs by Ernie Button except pp. 154–155 by Christopher Coates.
Design by Jon Glick.

10 9 8 7 6 5 4 3 2 1

Chronicle books and gifts are available at special quantity discounts to corporations, professional associations, literary programs, and other organizations. For details and discount information, please contact our premiums department at corporatesales@chroniclebooks.com or at 1-800-759-0190.

Chronicle Books LLC
680 Second Street
San Francisco, California 94107
www.chroniclebooks.com

# Contents

# On Whisky and Wonder

Charles MacLean

IT MAY COME AS A SURPRISE TO DISCOVER that the chemical compounds in mature whisky and other brown spirits which bestow flavor comprise less than 3% by volume of the contents of the bottle—less than 1% by weight—the rest of the liquid being alcohol (principally ethyl alcohol) and water, both of which are comparatively odorless and tasteless.

Yet it is this tiny amount that distinguishes not only one whisky from another, but Scotch whisky from bourbon or Irish whiskey, and indeed whisk(e)y from brandy, rum, and other brown spirits.

If you think this is extraordinary, bear in mind that a very pure spirit like vodka contains only .03% by volume of such compounds, which is the reason why vodka has so much less flavor than whisky. Early in his photographic investigation of whisky residues, Ernie Button applied his technique to white spirits—with poor results.

# *Congeners*

THESE SUBSTANCES ARE CALLED CONGENERS.* They might simply be described as "compounds you can smell and taste"—remember that flavor is, by definition, a combination of smell, taste, and texture (called "mouthfeel"), although we tend to think of flavor as being synonymous with taste.

Here is a list of the principal chemical groups that lend aroma to whisk(e)y and the scents typically associated with them:

| | |
|---|---|
| esters | pineapple, banana, apple, fruity, creamy, perfumed, acetone, coconut (oak lactone) |
| aldehydes | leafy, green, unripe fruit, vanilla, cinnamon |
| furfural | (an aldehyde) caramel, honey, nutty, malty |
| phenols | medicinal, iodine, carbolic, smoky, cloves |

In the *Journal of Applicable Chemistry* (1969), J. H. Kahn reported that 226 compounds had been observed in mature whisky, organoleptically (by nose and taste) and analytically (by liquid-gas chromatography). Since then this figure has been increased to over 300.

The relevance of all this to Mr. Button's astonishing photographs is, I believe, that it is these congeners that remain in the glass after the whisky has been drunk and has evaporated that create the beguiling imagery.

---

* Alcohol congener analysis of blood and urine is commonly used by courts to provide an indication of the type of alcohol consumed by someone accused of drunk driving, or worse. It can play a crucial role in cases when the driver is apprehended some time after the incident and, on returning a positive alcohol reading, then claims that this was due to drinking alcohol only after the event.

# "The Wood Makes the Whisky"

UNTIL THE 1980S IT WAS GENERALLY BELIEVED that it was the nature of the water used by any distillery that was the key influence upon the spirit's character. In his major work,* the leading authority on the science of distilling, J. A. Nettleton, devotes only three pages to the influence of wood maturation in a tome of 606 pages.

But the men who made the whisky knew better. They had a saying—"The wood makes the whisky"—and this is universally acknowledged today, with some distillers even claiming that up to 85% of the flavor in mature whisky comes from the cask.

While I think this is something of an exaggeration, there is no doubt at all that the chemical compounds in the spirit are radically modified during maturation—undesirable flavors are removed, desirable flavors (and color) leech from the wood itself, the capacity of oak to allows the spirit to "breathe" and interact with the surrounding atmosphere—and this causes complex and beneficial chemical changes in the spirit, developing new congeners.

My mentor, the late Dr. Jim Swan, one of the leading sensory chemists of our time, described the metamorphosis of spirit into whisky through maturation as follows: "Imagine the spirit to be a caterpillar. It fills the cask/becomes a chrysalis, then after a period of time emerges as a butterfly." A total transformation.

Ernie Button wrote to me: "Wood is the magic ingredient that makes these patterns come alive, become more complex." I have mentioned that he applied his method to white spirits without success, probably because of their purity (i.e., their lack of congeners), and later to barrel-aged gin, tequila, rum, and vodka, but with only slightly better results.

---

* J. A. Nettleton, *The Manufacture of Whisky and Plain Spirit* (Aberdeen: G. Cornwall & Sons, 1913).

# Complexity

SCOTCH MALT WHISKY IS UNIVERSALLY ACKNOWLEDGED to be the most complex spirit in the world. This is developed by maturation in oak casks—since 1990 the casks *must* be made from oak, although this was always the wood of choice—and by the length of time the whisky has been left to mature. So important are these factors that they have been described as "the fourth and fifth ingredients in malt whisky"—the first three being simply malted barley, water, and yeast.

Scotland's cool, damp, climate allows for very long maturation. In warmer climates—Kentucky, Taiwan, India, for example—maturity is achieved much more rapidly. Indeed, long maturation under such conditions can lead to the whisk(e)y being spoiled, dominated by flavors arising from the wood. Some distillers claim, with some justification, that one year's maturation under such conditions is equal to four years in Scotland: MacDowell's Distillery in Goa, India, released an edition labeled "12." In tiny letters under the age statement was "seasons"!

In 1994, F. Paul Pacult—recently described by *Forbes* magazine as "America's foremost spirits authority"—was asked by Glenmorangie Distillery to comment on the flavor development of their product over time. He wrote:

> The new spirit, straight from the still, is ethereal and quite estery. The top notes are fruity apple, with a hint of lemon. After 10 years maturation there is a tremendous difference in fragrance character. The apple notes are still present, but behind them a totally different accord: a soft rose nuance in conjunction with a warm spice effect, giving a warmth the new spirit does not have. A honey, liquorice note is beginning to emerge . . .
>
> And the 18 Year Old? A blackcurrant note has now become identifiable. The sweetness is more noticeable: chocolatey in character. To support and enhance the bouquet, a tobacco-leaf nuance can be detected.*

Glenmorangie then invited the Parisian perfumer, Christian St. Roche, to assess the aromatic volatiles in their 10 Years Old malt. He named 26 aromas, from almond, bergamot, and cinnamon to quince and vanilla. The distillery then approached the internationally renowned fragrance house Belmay Inc., of Long Island, New York, and asked

---

\* Quoted in *The Tain Conundrum: A Highland Mystery* (Tain, 1994).

them to assess both 10 and 18 Years Old expressions. Their expert panel named 22 aromas in 10 YO and 17 in 18 YO, but only eight of their descriptors coincided with those of St. Roche.

What impressed Edward Schwartz, head perfumer at Belmay, was how the aromatic profile in the younger malt evolved into that of the older. For example, lemon/mandarin became orange; apple/mint/banana became plum/raisin; tobacco leaf became sandalwood.

## Visualizing Aroma

IS IT TOO FANCIFUL TO SUPPOSE that Ernie Button's ethereal images might offer clues to the flavor profiles of the individual malts? Might the circular patterns in some of the photographs relate in some way to the age of the whisky, like the growth rings on a tree? Might the luminous landscapes they conjure up, and their fractal repetitions, tell us something about where the whiskies were made? Such thoughts are whimsical and nonscientific, but they appeal to me.

From a purely aesthetic perspective, Ernie's photographs are mysterious, spectral, otherworldly, organic, calming, and beautiful. They are abstract; but since they are grounded in reality, rather than being mental constructs, they communicate a timelessness, such as exists in outer space or existed at the dawn of Creation. They stimulate subjective interpretation.

Some speak to me of fossils and seashells; agates, crystals, and cut jewels; deserts, snowfields, seas, and coastlines; molten lava; ancient cities lost to desert and pestilence—Anuradhapura, Nineveh, Ur. Elemental.

Indeed, Scotch malt whisky has been described as "an elemental elixir . . . a creature of infinite capacity . . . a complicated simple, the whisky, pure in essence but diverse in effects; and against it none can prevail."[*] Somehow, these wonderful photographs capture the spirit's essence.

Enjoy this book. Let your mind wander—and wonder!

Charles MacLean, M.B.E., Master of the Quaich
Edinburgh

---

[*] J. P. McCondach, *The Channering Worm* (Edinburgh: Canongate, 1983).

# Vanishing Spirits

Ernie Button

ONE OF THE MANY SPECIAL THINGS THAT DREW ME TO PHOTOGRAPHY more than 20 years ago was the magic of working in the darkroom. It was an otherworldly experience to watch a blank piece of paper, resting in a Dektol solution, as it slowly revealed images that I had captured through my camera. Some years later I would find that same feeling of wonder watching equally mysterious imagery reveal itself at the bottom of a glass of Scotch whisky.

The idea for this project came to me when I put a used Scotch glass into the dishwasher after the glass had been left out overnight. As I did so, I noticed a patterned film of fine lines on the bottom of the glass where the dregs of my whisky had dried. Because my studio is perpetually set up for close-up photography, I immediately took the glass into my studio to see how it would look on film. I am now shooting digitally; at the time, I was shooting medium format film.

Through experimentation, I confirmed that these patterns of lines can be created with just the smallest residue of whisky left in a glass and that nearly all aged whisky will produce the lines, given the right conditions. My first photographic challenge was to find the dried remains that would offer an interesting pattern or design when magnified under the camera lens. I discovered that, depending upon drying time, age of whisky, humidity, alcohol content, and glass shape, every result is unique, much like snowflakes.

My process involves using different-color lights and filters to enhance the residue texture at the bottom of the glass. From start to finish, it takes about 10 hours to produce the final image in each glass, including all of the various lighting setups, angles, and later post-processing. As my research continued, I discovered that because the dried remains retain the scent of the whisky for several days, my studio has the subtle bouquet of Scotch on the days when I am working on this project.

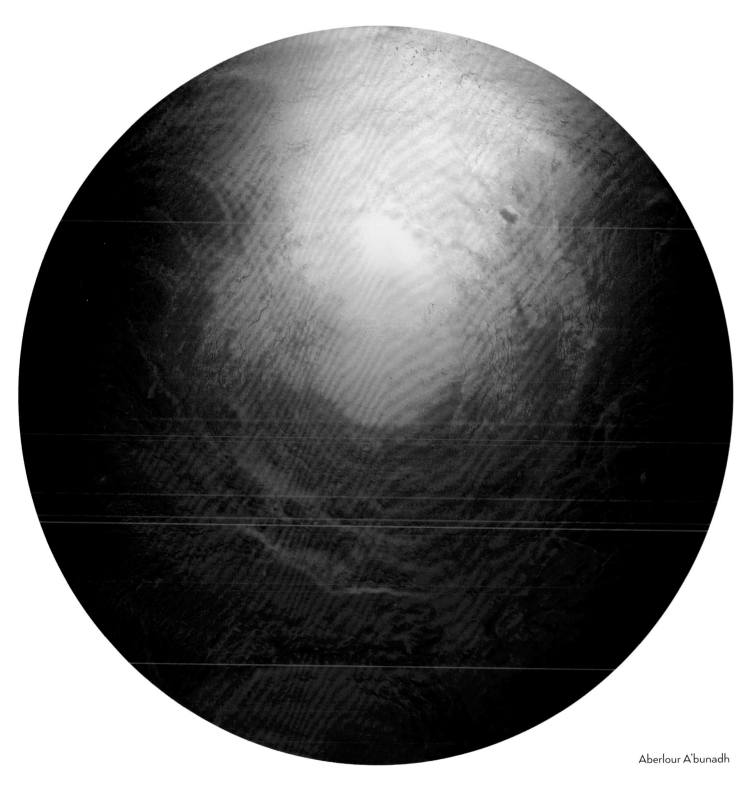

Aberlour A'bunadh

I have been a photographer for virtually my entire adult life, exhibiting my photography for over 20 years. I have always keenly observed the world around me, where I especially enjoy noticing the smaller details that otherwise may be ignored or overlooked. This ability to observe the smallest details led me to the Vanishing Spirits. I am drawn to photograph things that I can study and reflect upon. Subjects that suggest something beyond the form itself make the complexity and detail of these images even more intriguing. About two years into the project, I started to see the illusion of terrestrial and extraterrestrial landscapes reveal themselves in my images, so I started to emphasize more dramatic lighting and closer cropping of the images to help accentuate the landscape patterns in those select images.

The images of deep space recorded by the Hubble telescope have long fascinated me, so when I saw that my lighting experiments were yielding cosmic-like results, this revelation influenced and helped shape the project's vision. I enjoy getting lost in the possibility that these lines and shapes may be visions of new planets or solar systems, or places here on Earth as yet to be discovered.

The scenic photographs that begin each of the chapters of this book were taken in Scotland—a beautiful, photogenic country—using a plastic camera called a Holga, which is my travel camera. It is a cheaply made medium format film camera with a plastic lens. It is prone to light leaks if the body isn't properly secured with tape. There is no way to adjust shutter speed or aperture, so you get what you get, often giving parts of the final images a slightly hazy or dreamy quality. I find that these moments of imperfection in the photographs mirror my personal recollections of travel: Some elements are sharp in memory, others less distinct.

I have been working on this Vanishing Spirits imagery for about 15 years. It is my tribute to the amazing complexity of Scotch whisky, which is born of just three ingredients—water, yeast, and barley—with crucial years spent resting in an oak cask. It is also a testimony to the talented people whose expertise and dedication bring that dram of finely crafted whisky to the palate.

I give my wife, Melissa, credit for the genesis of this project; she came from a Scotch-drinking family and thus exposed me to the appreciation of a fine whisky. And although I have been fortunate to have received a few gift bottles (and a few samples I specifically requested), the whisky used to create the vast majority of these images was from bottles Melissa and I purchased and enjoyed over the many years of this project.

I hope that my images convey a deeper appreciation of the craft, complexity, and magic inherent in Scotch whisky; and I encourage you to appreciate and enjoy "the water of life" on a deeper level and through a new lens.

**Slàinte.**

# The Fluid Dynamics of Whisky

Howard A. Stone

I DRINK A GLASS OF WINE ONLY EVERY COUPLE OF WEEKS, usually while enjoying dinner at a restaurant with family or colleagues. I rarely drink hard liquor. So you might wonder why I am writing for *The Art of Whisky* by Ernie Button, which displays his beautiful and enchanting images of the patterns formed after the remnants of whisky have dried in the bottom of a glass.

I am a professor of mechanical and aerospace engineering at Princeton University. My research interests are in fluid mechanics, which refers to circumstances where a gas, liquid, or other liquid-like material (such as tomato sauce, toothpaste, etc.) flows. Fluid mechanics span a wide range of science and engineering problems, including the flows involving airplanes, coating processes, and painting, and the motion of biological cells. My focus is areas where the "length scale" of the flow is relatively small, e.g., centimeters and smaller for ordinary liquids.

Some of the fluid dynamics problems I study involve beverages. For example, some researchers seek to understand "wine tears," also referred to as the "legs" in a glass of wine; or they may be interested in the change of phase that occurs when water is added to ouzo, or why patterns in layers can form when making a caffe latte. Another example that occurs with a favorite drink are coffee stains, the ring-shaped deposits that appear after spilled coffee evaporates. Life is full of wonderful surprises and scientists as well as nonscientists appreciate patterns found in nature.

Ernie reached out to me about my research in these areas via email shortly before Christmas in 2012. He described his photographs of the dried remains of single-malt Scotch, "essentially Scotch rings," and wondered if I could help him understand more about the lines and patterns at the bottom of the glasses. I had previously studied aspects

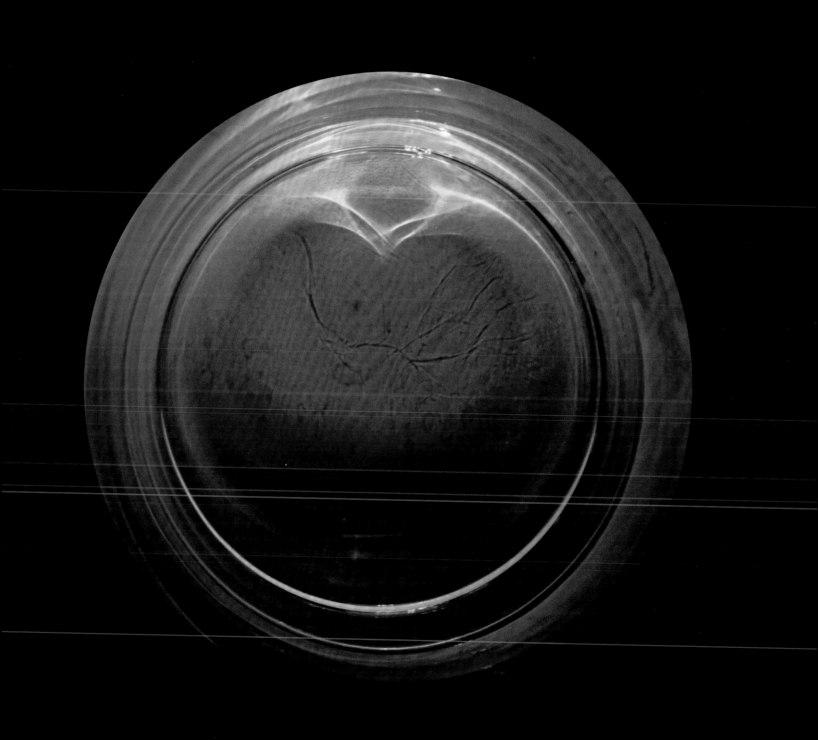

of the evaporation of thin liquid films. I sent Ernie a paper I had written with my research group in 2002 that showed the drying patterns formed by a drop of latex solution (essentially, water containing small particles of latex). Ernie and I corresponded further and, as I recall, I went to a liquor store to buy some whisky for research, but with other day-to-day distractions, I did not investigate much more at the time.

Ernie and I were in touch again over the summer in 2013. At this time, I encouraged two researchers who worked with me, Dr. Ian Jacobi (now an assistant professor of aerospace engineering at the Technion in Israel) and Dr. Eujin Um (now an assistant professor of biomedical engineering at Ulsan National Institute of Science and Technology in South Korea), to make some measurements when they were taking a break from their regular research. Ian and Eujin had the good idea to learn more about the whisky-making process and to identify the particulate-like materials in whisky that form the patterns We understood that both the grain used and the organic materials from the wood were likely significant.

Over the next year, two other researchers, Hyoungsoo Kim (now an assistant professor of mechanical engineering at KAIST in South Korea) and François Boulogne (now a researcher with the CNRS and Paris-Saclay University in France), also began to study the question. Their expertise looking "inside" fluids to measure the flow patterns helped them recognize that many industrial coating flows may utilize two components, in a similar way to the ethyl alcohol and water that constitute the main ingredients of whisky. Although evaporation of a single component liquid (such as water or ethyl alcohol) containing suspended particles forms rings of particles (e,g., coffee stains), Ernie's photographs were different; they showed more uniform coatings. Thus, we were inspired to seek the properties of the liquid that allowed a uniform coating, since that could have applications in materials science. In our case, we looked to whisky for a hint.

The two main components of whisky, water and ethyl alcohol, have different vapor pressures. The alcohol evaporates more rapidly (sniff a glass of whisky to verify this fact). This changes what is called *surface tension* at the boundary between the liquid and the air. In fact, the evaporation is expected to be nonuniform over the surface of whisky, and this leads to fluid motions in the drying liquid film. The motions, called *Marangoni flows*, are created when the surface tension changes along a film and are named after a nineteenth-century Italian scientist, Carlo Marangoni. They are also responsible for the

"legs," the droplets one can see on the inside of a glass of wine. The flows help make the final patterns more uniform. In experiments we performed in the laboratory with model liquids mimicking whisky, we obtained patterns similar to Ernie's photographs only when we included in the solution some polymer (long molecules), which we speculate is responsible for helping particulate materials adhere to the glass. The adhered particles are what give the photos their striking imagery, and are likely created during the whisky fermentation process.

Our understanding of many details advanced; and we even gave a talk on the subject at the annual meeting of the Division of Fluid Dynamics of the American Physical Society (the largest organization of physicists in the world); such conferences are opportunities to share research with colleagues around the world. At the last minute we changed the title of our paper from something (boring) about an evaporating liquid to a title including the word "whisky." Suddenly, many more people were interested in the work! Ernie's work even got the attention of the *New York Times* in November 2014, and the writer contacted me for some input.

Basic research is often slow when the goal is understanding, with experiments to allow measurements and explore different hypotheses, and mathematical modeling to understand the different qualitative and quantitative features observed. The traditional approach is to then write a research paper and have it peer-reviewed by experts in the field. And so, after several years, our paper appeared in print, including an image on the journal cover.* The results link to Ernie's beautiful photos and how they inspired him to learn more about the science behind them. Readers of this book are in for a visual treat.

---

\* H. Kim, F. Boulogne, E. Um, I. Jacobi, E. Button, and H. A. Stone, "Controlled Uniform Coating from the Interplay of Marangoni Flows and Surface-Adsorbed Macromolecules," *Physical Review Letters* (cover image) (2016): 116, 124501.

# The Whisky Regions of Scotland

Charles MacLean

THE SCOTCH WHISKY TRADE HAS BEEN AWARE OF DIFFERENCES in the flavor of whiskies coming from different parts of Scotland for a very long time—at least since the 1780s, when a notional line was drawn diagonally across the country, defining "the Highlands" and "the Lowlands." Different taxes and other legal requirements applied above and below the "Highland line," resulting in different styles of spirit.

With the boom in blended Scotch during the latter half of the nineteenth century, whisky companies began to look more closely at the flavor characteristics not only of individual distilleries but of subregions, and by the end of the century the blenders had subdivided Highland region into Strathspey (now known as Speyside), North Highland, Islay, and Campbeltown.

During the 1980s there was a huge growth in interest in single malt whiskies, and consumers familiar with regional differences in wine were quick to grasp the idea of regional differences in malts. So the old blenders' classifications, which were not originally shared with the consumer, proved invaluable. They are reflected in the current regulations, which identify five regional styles of malt whisky: Speyside, Highland, Islay, Campbeltown, and Lowland.

Although the flavor profile of any malt whisky cannot be precisely copied in another distillery—the variety of Ernie Button's images stand witness to this—increased understanding of how flavor is created during production and maturation has tended to blur the differences between malts coming from one region and another. Nevertheless, broad characteristics may be discerned, and these are set out in what follows.

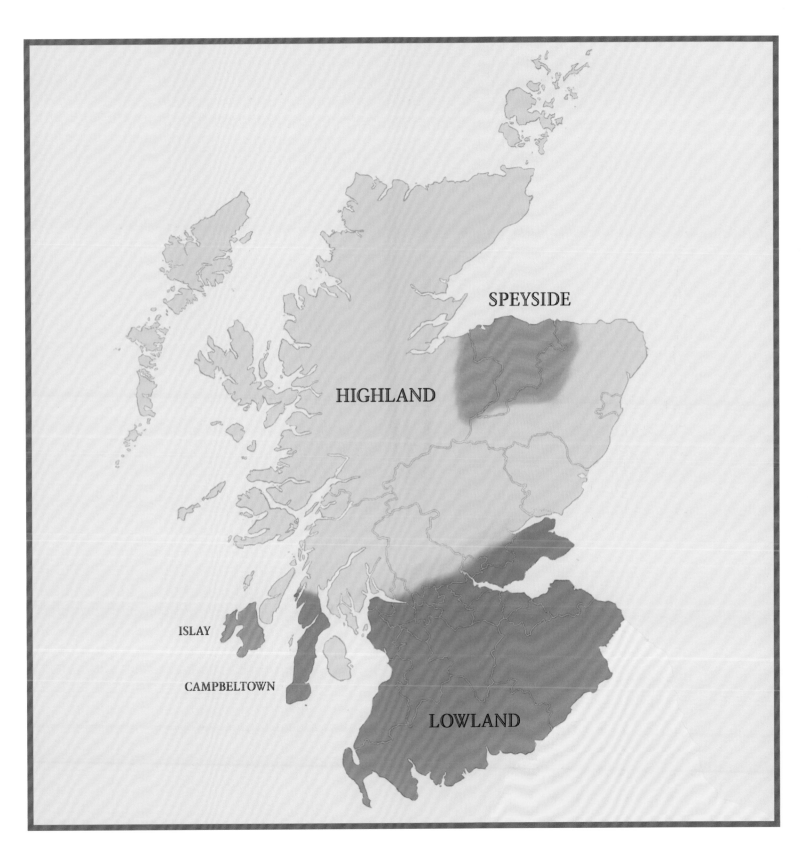

SPEYSIDE

HIGHLAND

ISLAY

CAMPBELTOWN

LOWLAND

# SPEYSIDE

## The Speyside Malts

OVER A THIRD OF THE MALT WHISKY DISTILLERIES operating in Scotland today are designated "Speysides," situated around a broad strath, or valley, that roughly follows the River Spey from the Cairngorm Mountains into the fertile coastal plain of the Moray Firth.

The whiskies made here are generally sweet and fruity (pear drops, apples, cream soda, acetone). The lighter ones have floral notes (roses, Parma violets, carnations, hedgerows); the heavier ones—particularly those that have been matured in ex-sherry casks—are bigger and nuttier (dried fruits, kitchen spices, chocolate). Most distilleries use unpeated or very lightly peated malt, although in recent years a few have produced peated variants.

—C. M.

The Balvenie Castle

Convalmore Distillery

The Macallan Distillery

Speyside Cooperage

24

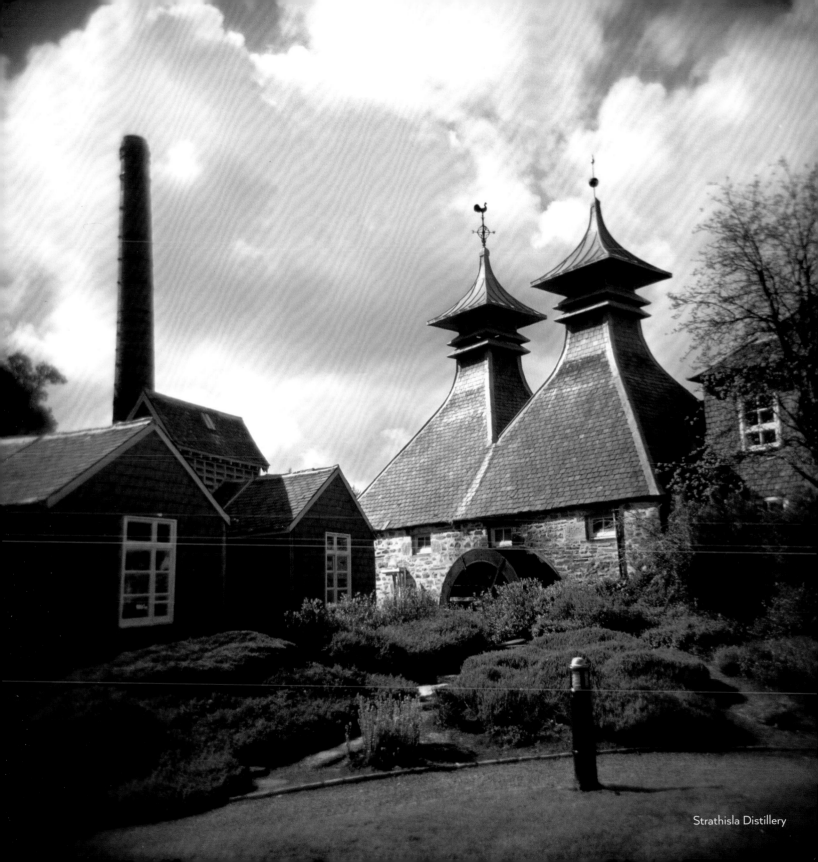

Strathisla Distillery

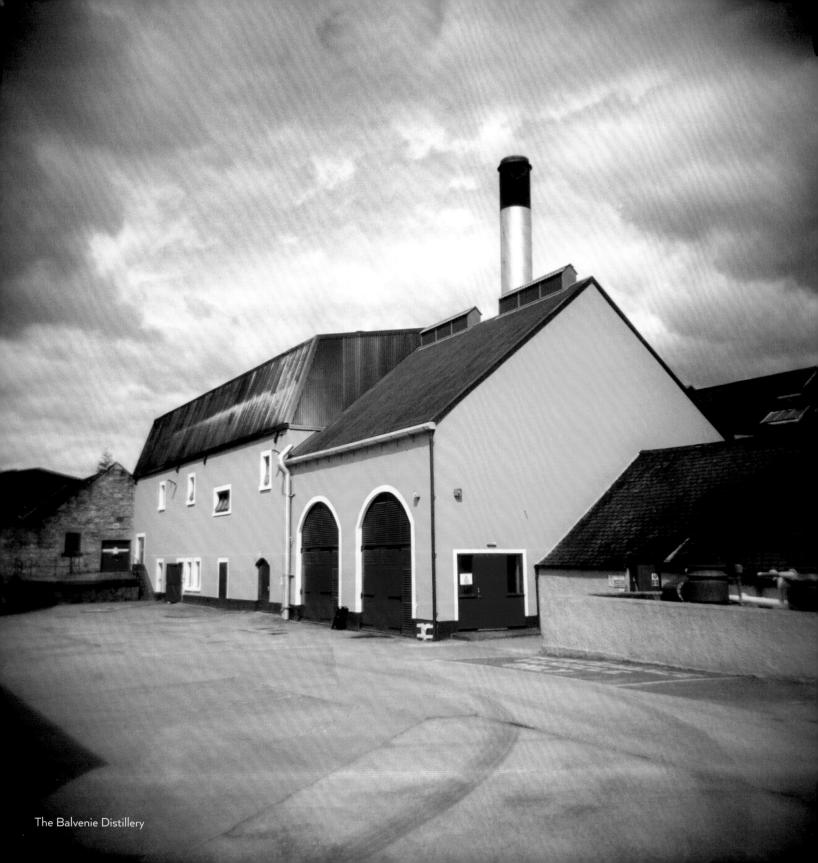

The Balvenie Distillery

Field of Barley

Aberlour Distillery

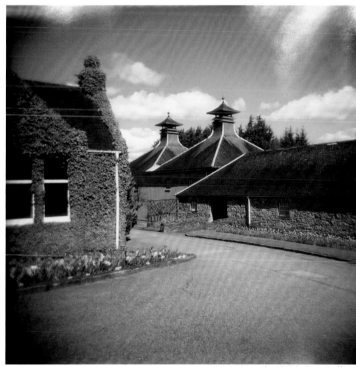

The Glenfiddich Distillery

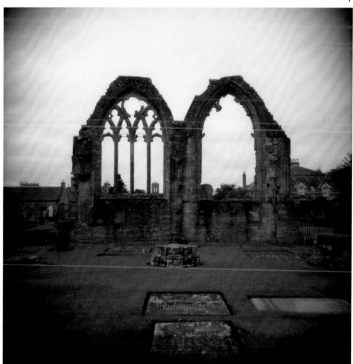

Elgin Cathedral

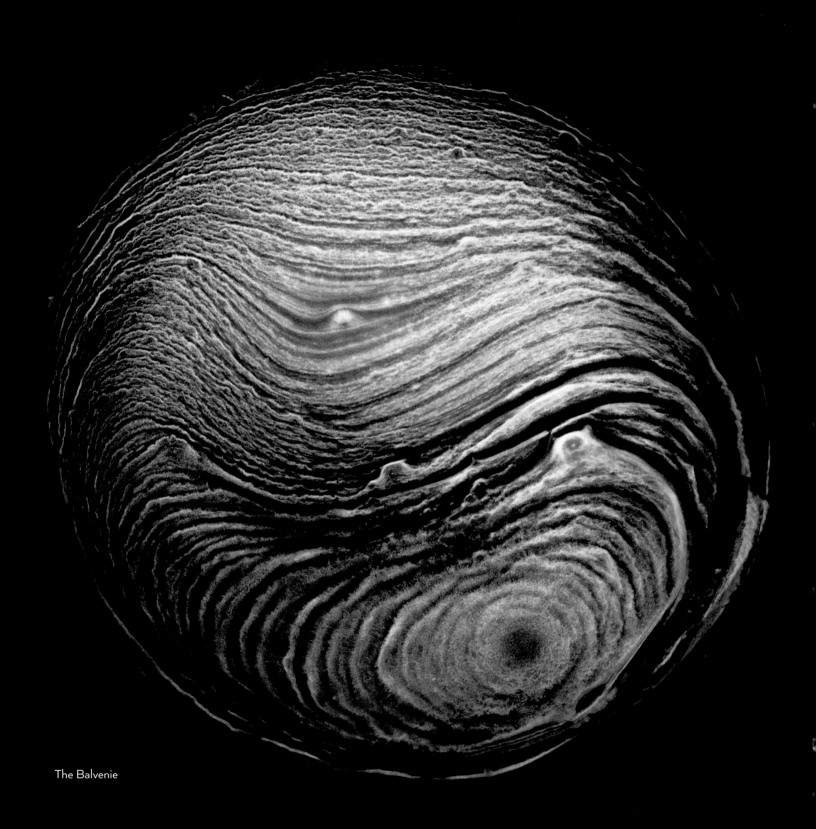

The Balvenie

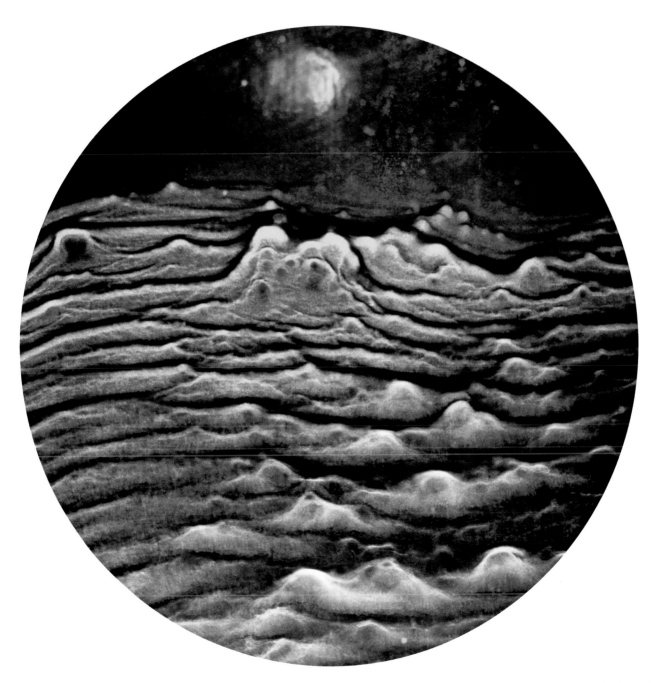

Aberlour A'bunadh

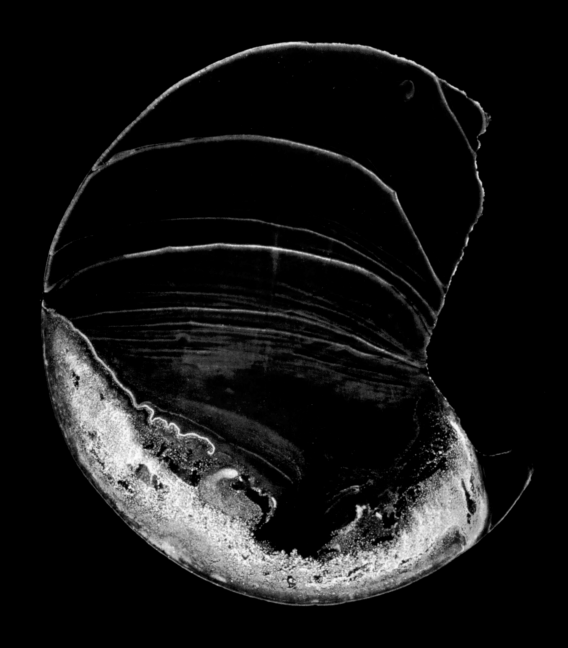

Glenfiddich New Make Spirit
5 Weeks in an Oak Cask

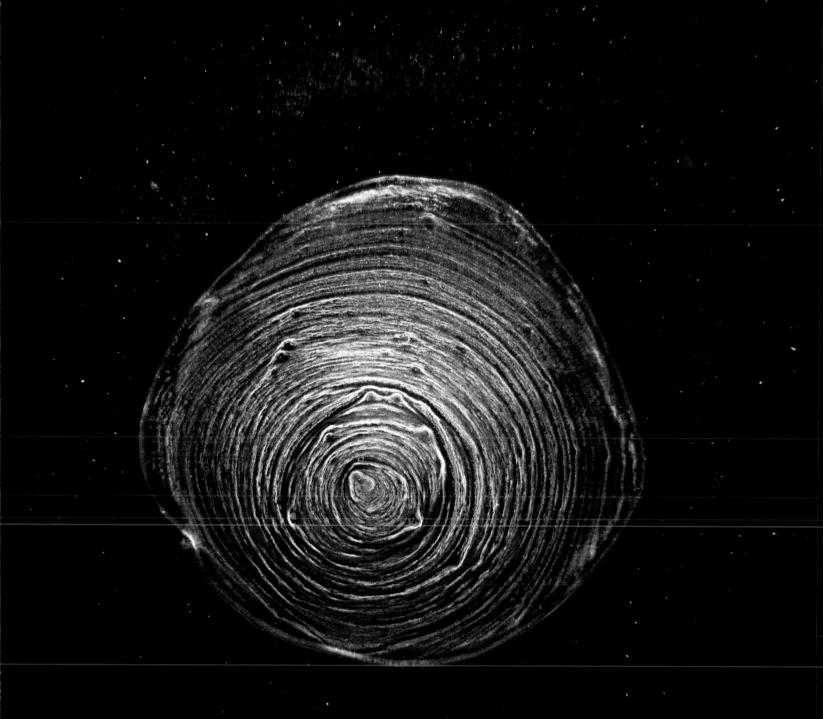

Glenfiddich XX

Planet Aberlour

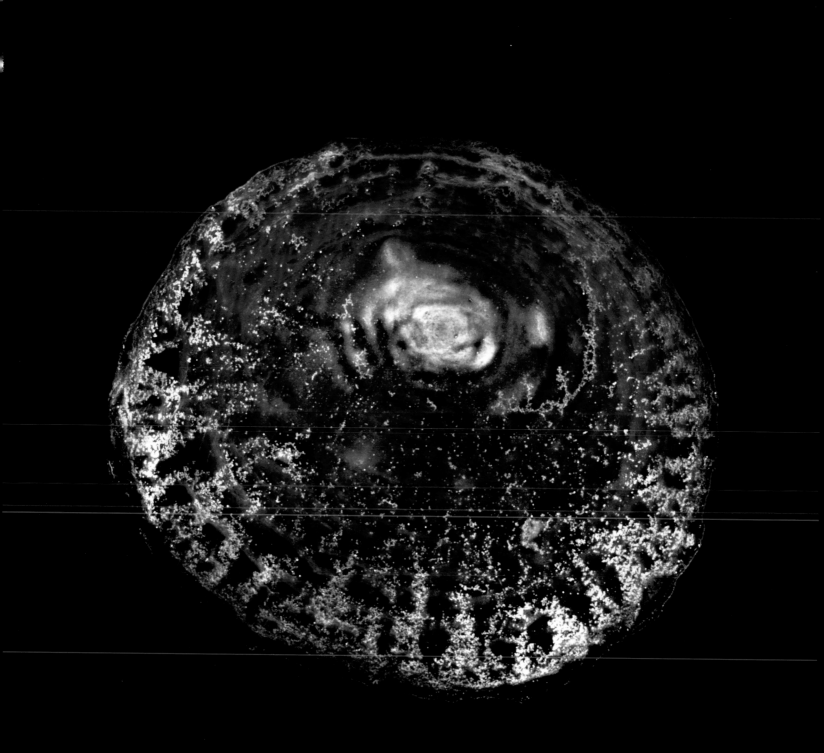

Glenfiddich Winter Storm

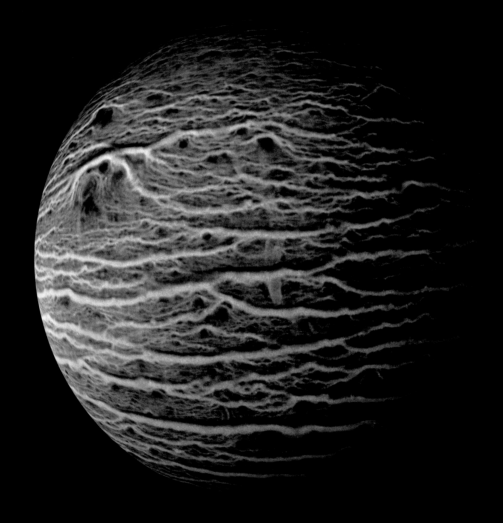

Planet Glenlivet 12 YO

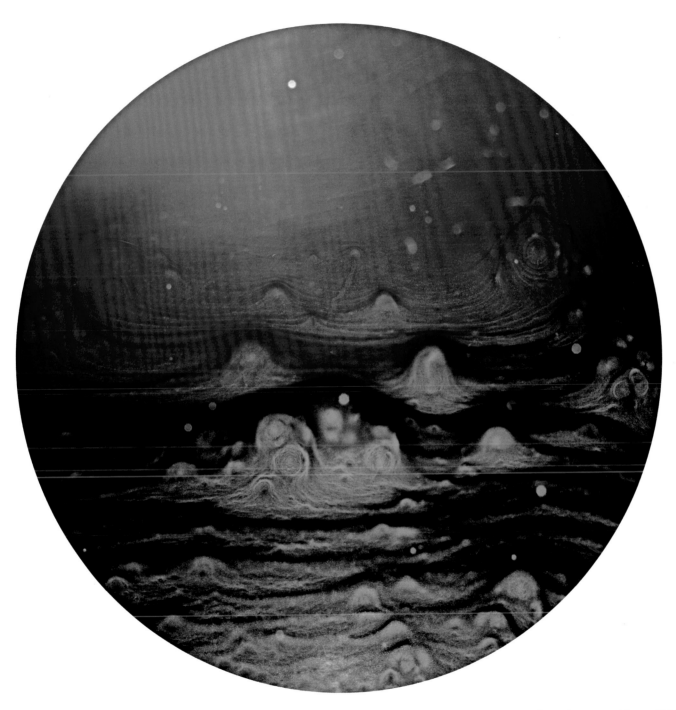

The Balvenie Doublewood 12 YO

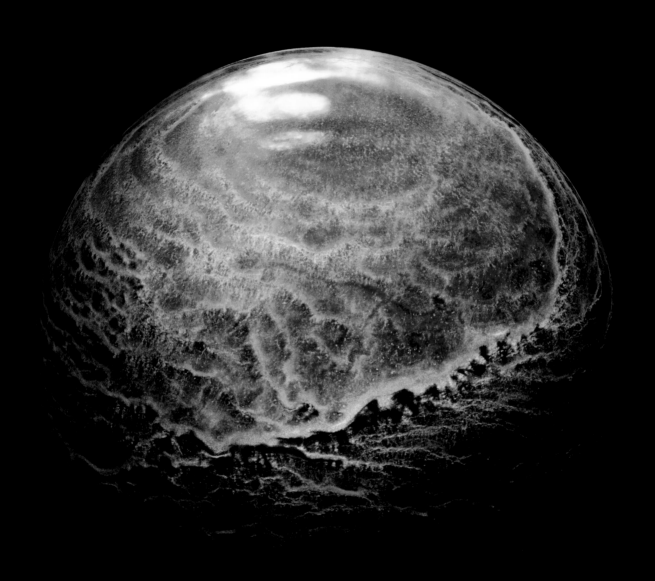

Planet Macallan

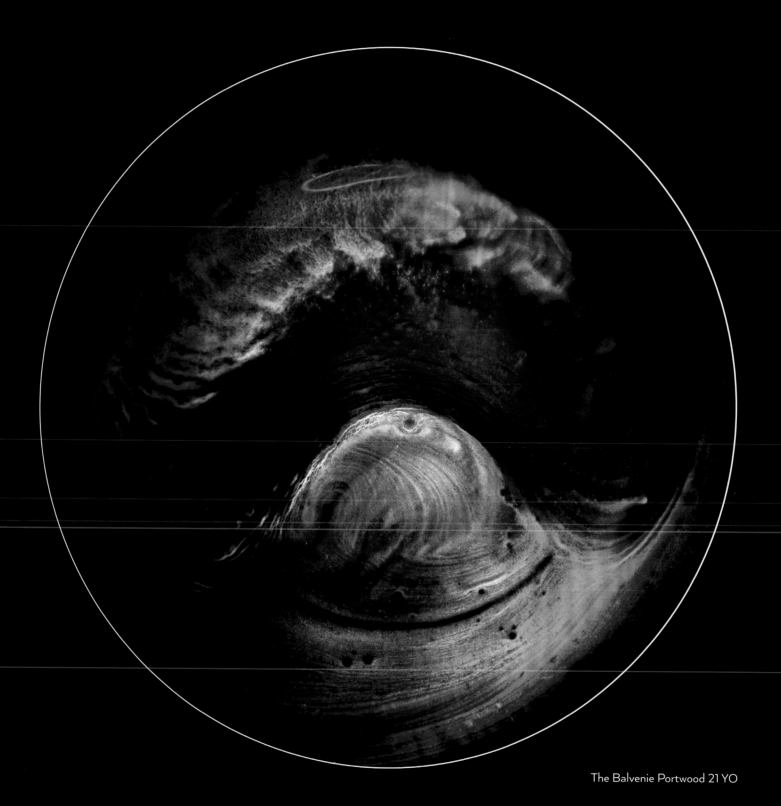

The Balvenie Portwood 21 YO

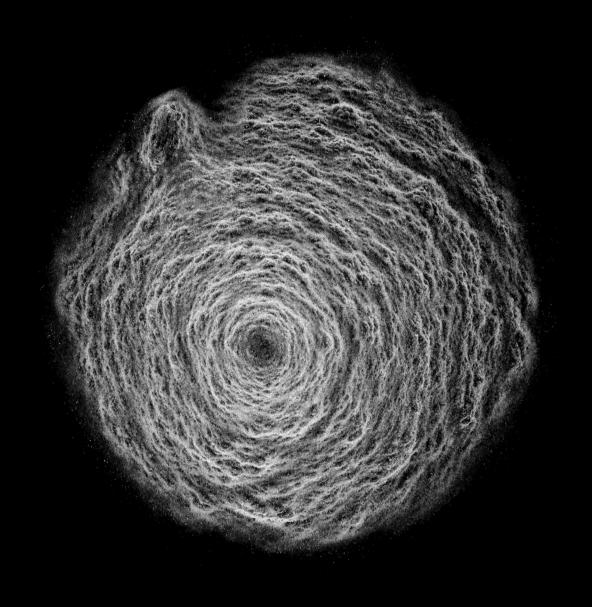

Tamdhu 15 YO

## TASTING NOTES

**NOSE:** An aromatic array of apple pastry, spiced currants, and orange zest, with exotic notes of pineapple and fennel.

**PALATE:** A burst of juicy apricot and vibrant raspberry, with lemon tart and creamy almonds on the palate.

**FINISH:** A rewardingly long journey through warming malt biscuit, cream sherry, and vanilla.

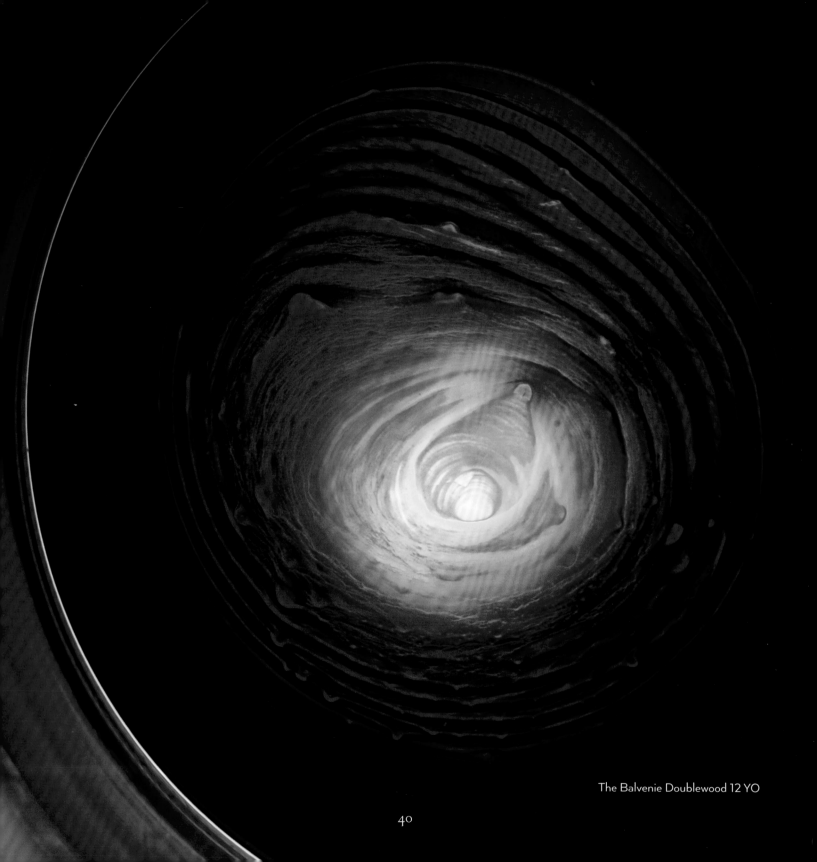

The Balvenie Doublewood 12 YO

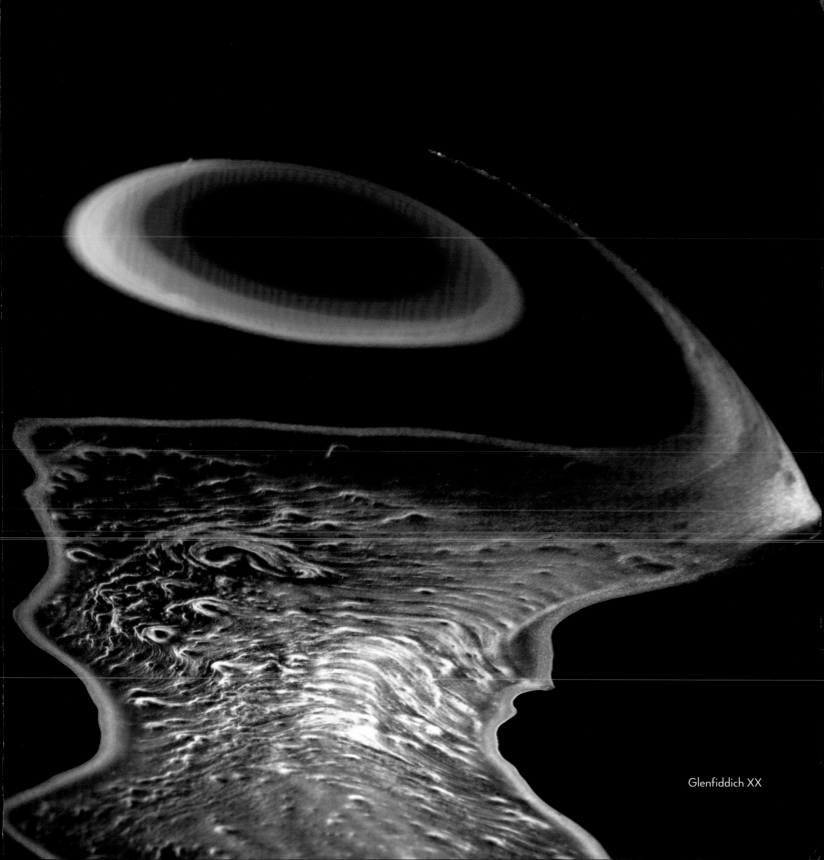

Glenfiddich XX

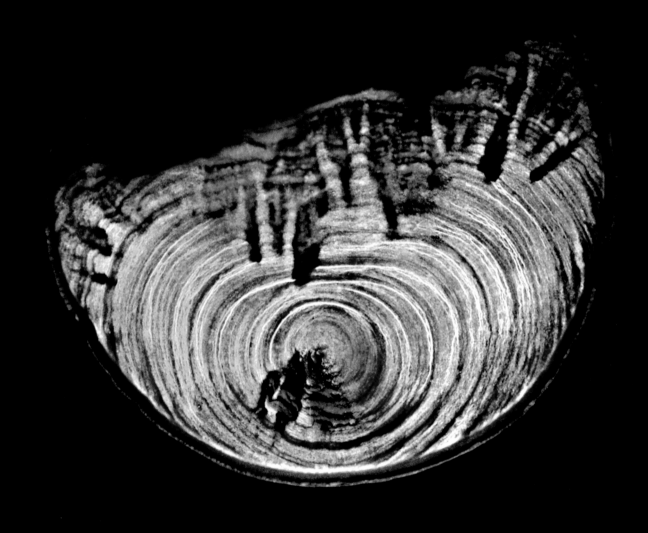

Glenfiddich Fire & Cane

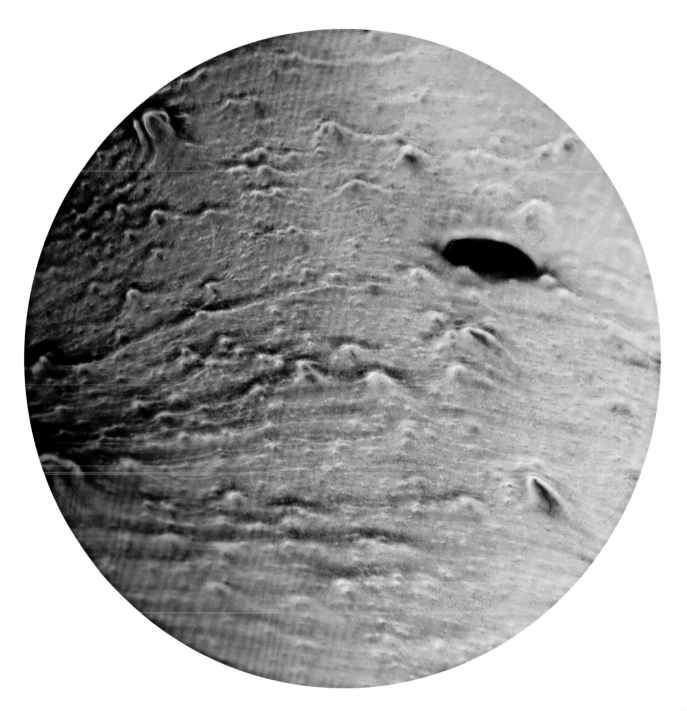

The Macallan

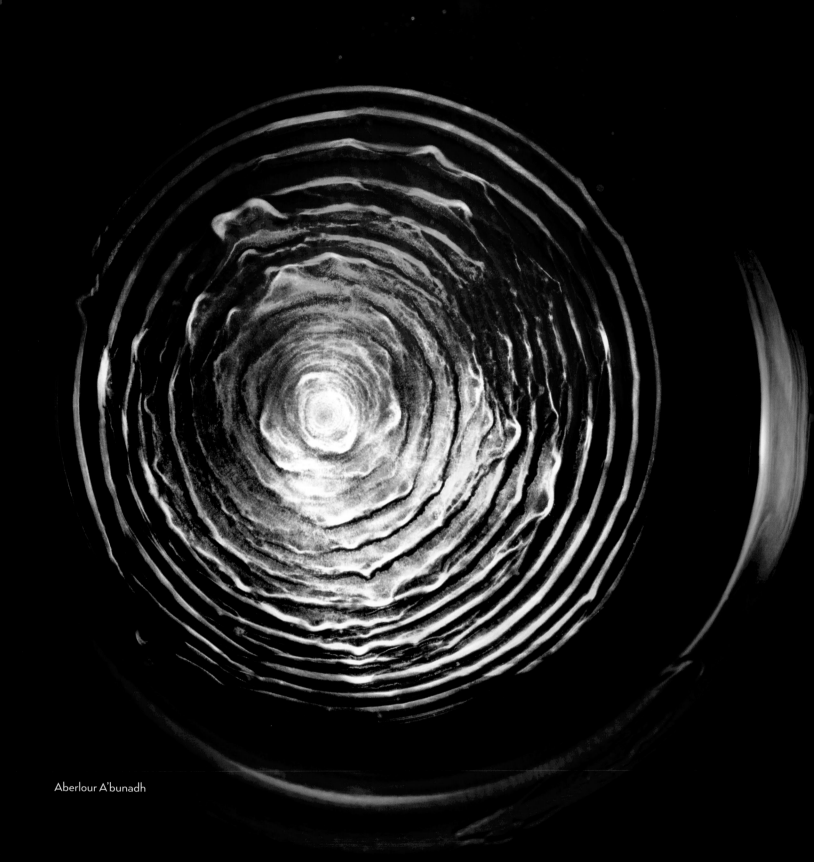

Aberlour A'bunadh

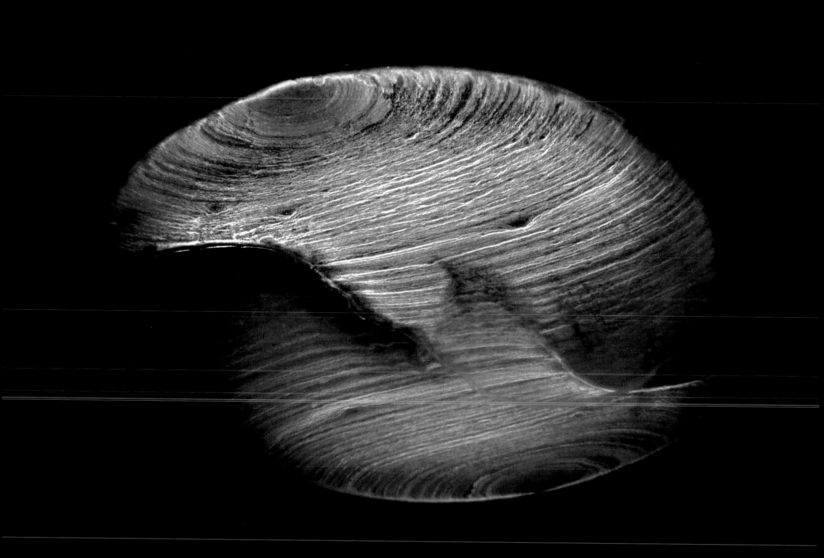

Glenfiddich Fire & Cane

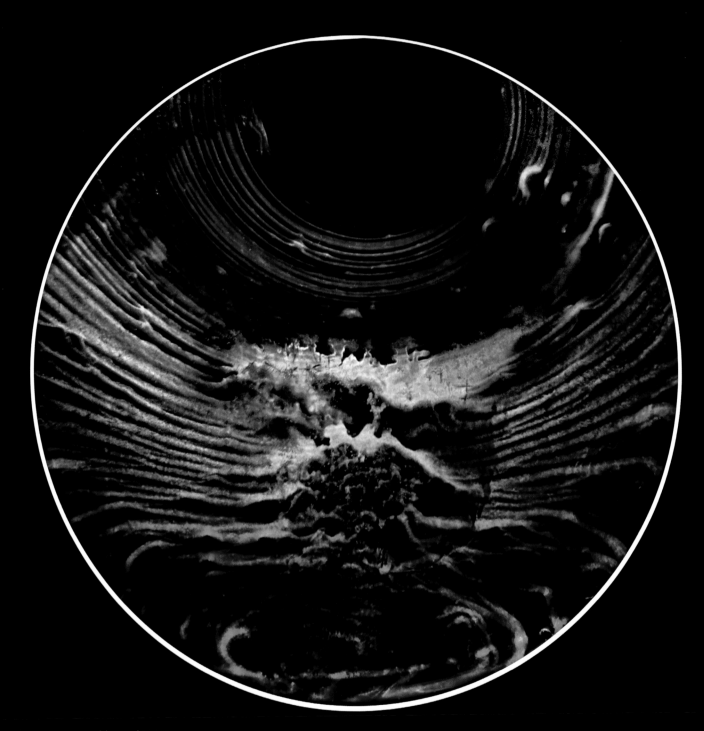

The Balvenie Doublewood 12 YO

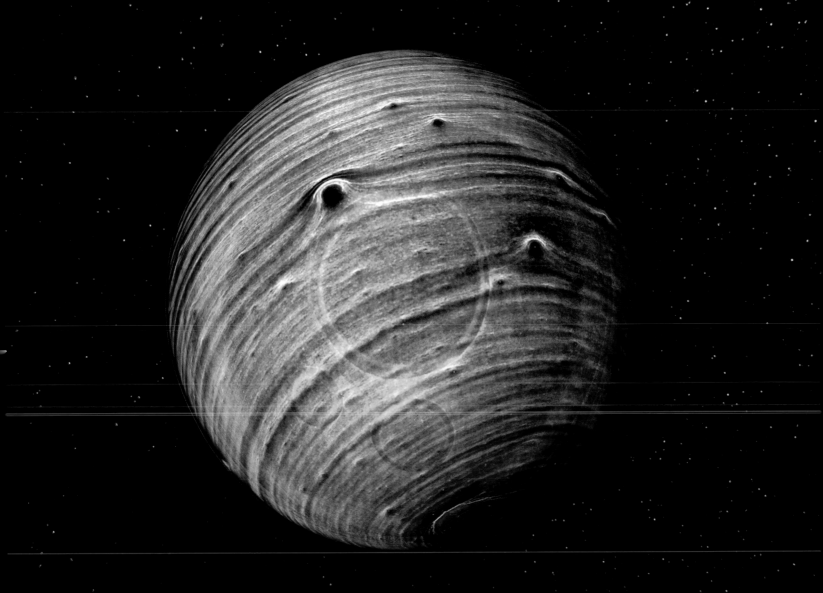

Planet XX

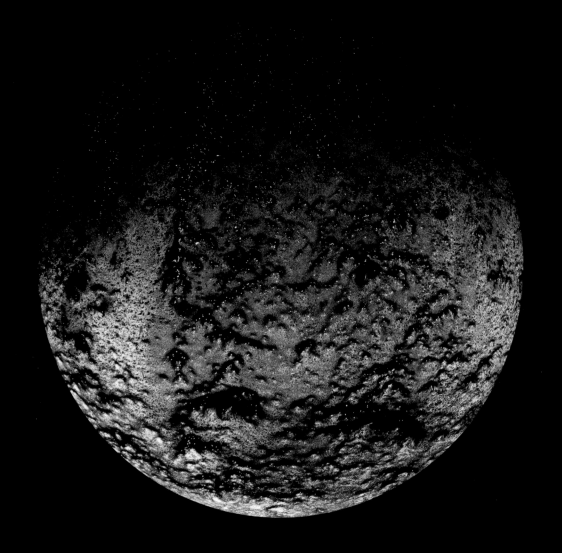

Planet Macallan

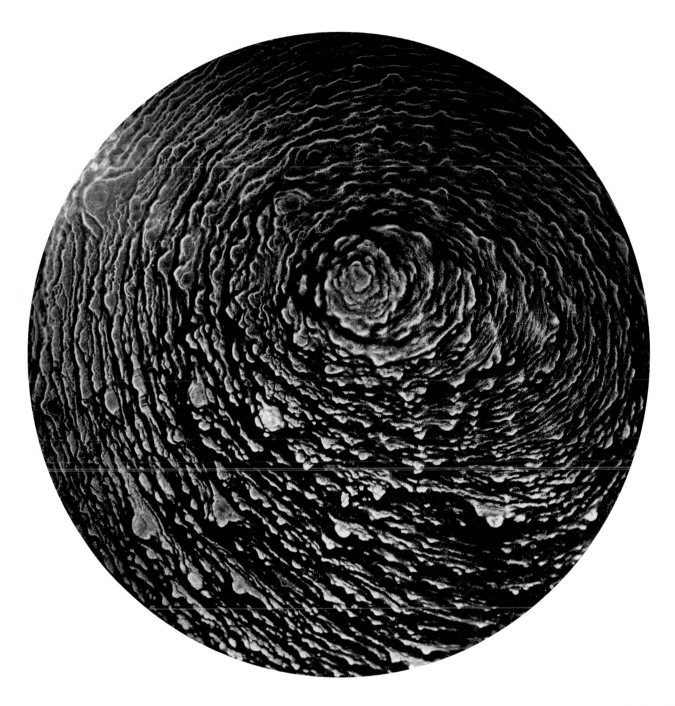

The Glenlivet 12 YO

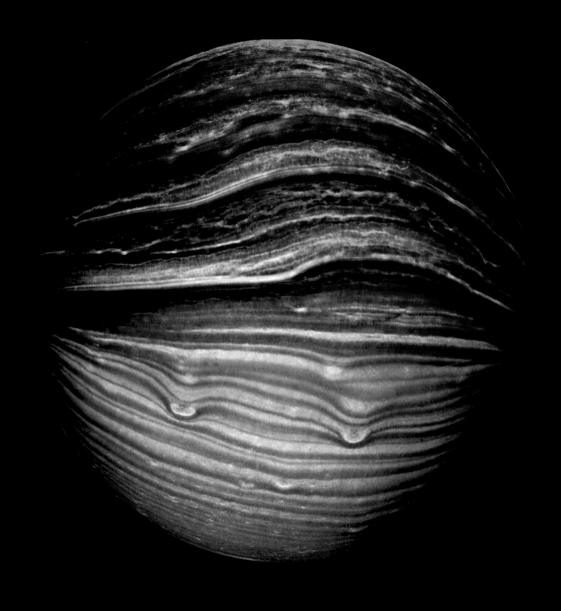

Planet Aberlour 13 YO

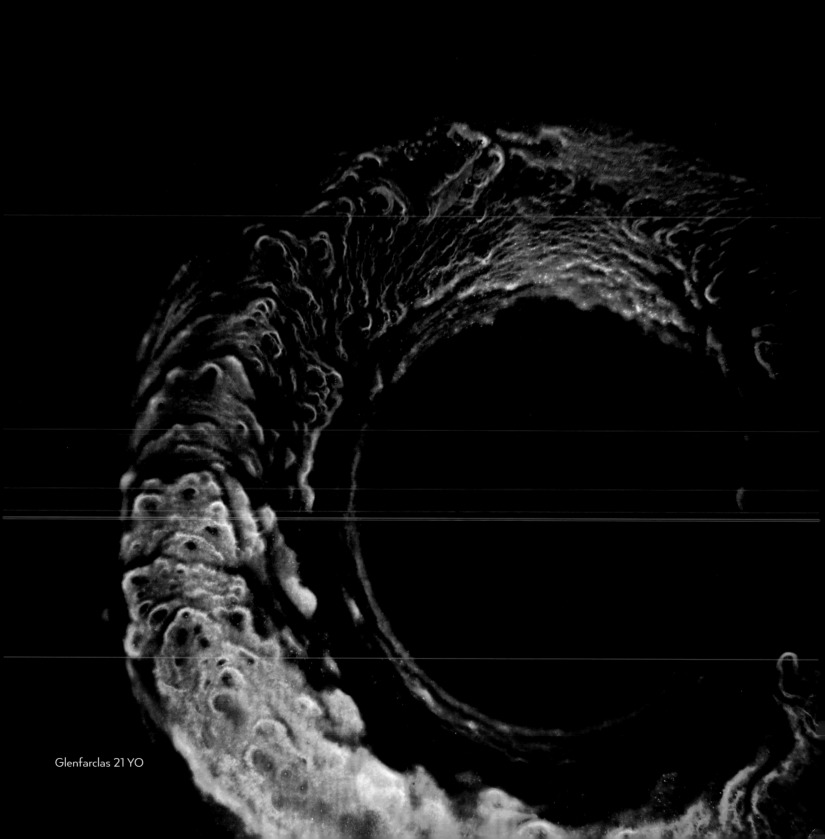

Glenfarclas 21 YO

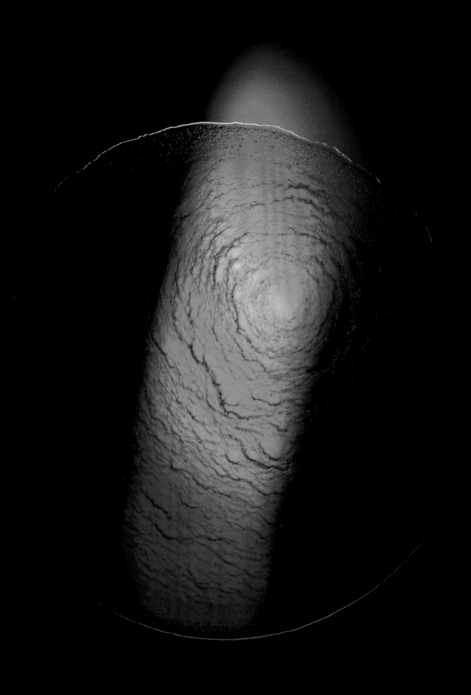

The Balvenie Doublewood 25 YO

## TASTING NOTES

A luscious combination of sweetness and spice with candied orange, some honey syrup, cloves, and ginger. The taste is rich, velvety, and mouth-coating with developing layers of brown sugar and sweet dried fruits, leaving a lingering and sumptuous finish of oak and sherried sweetness.

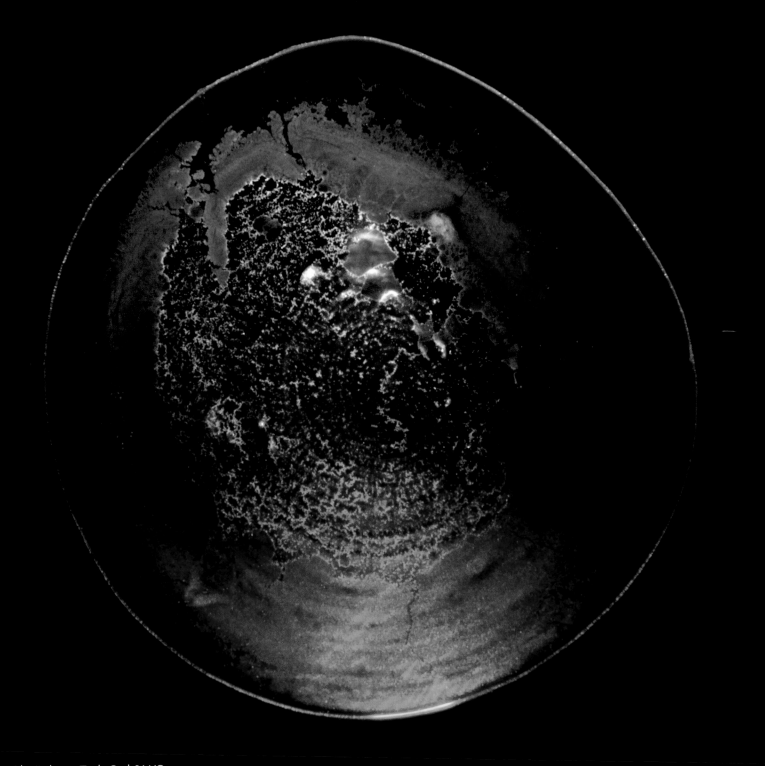

The Balvenie Triple Cask 16 YO

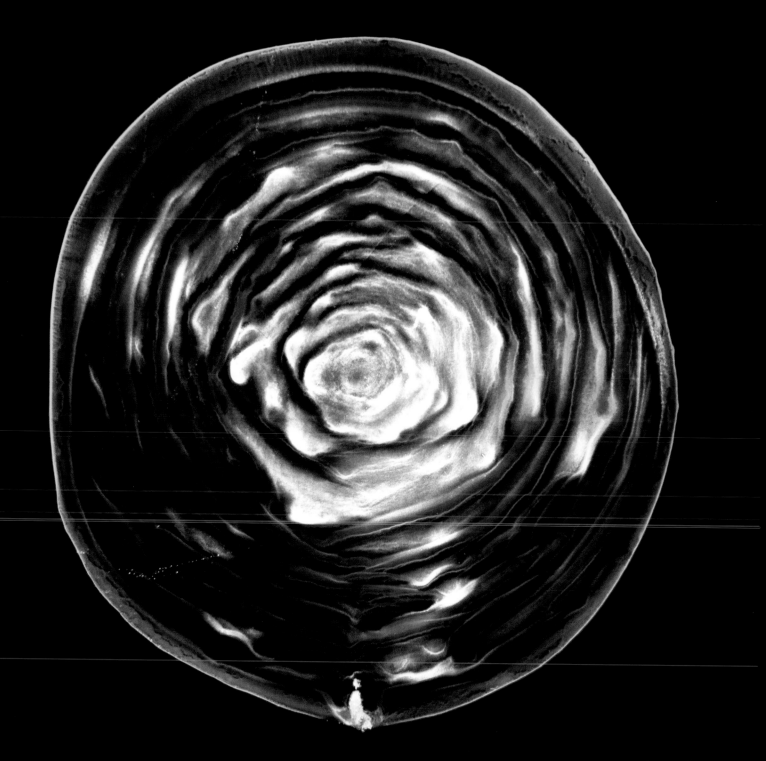

The Macallan

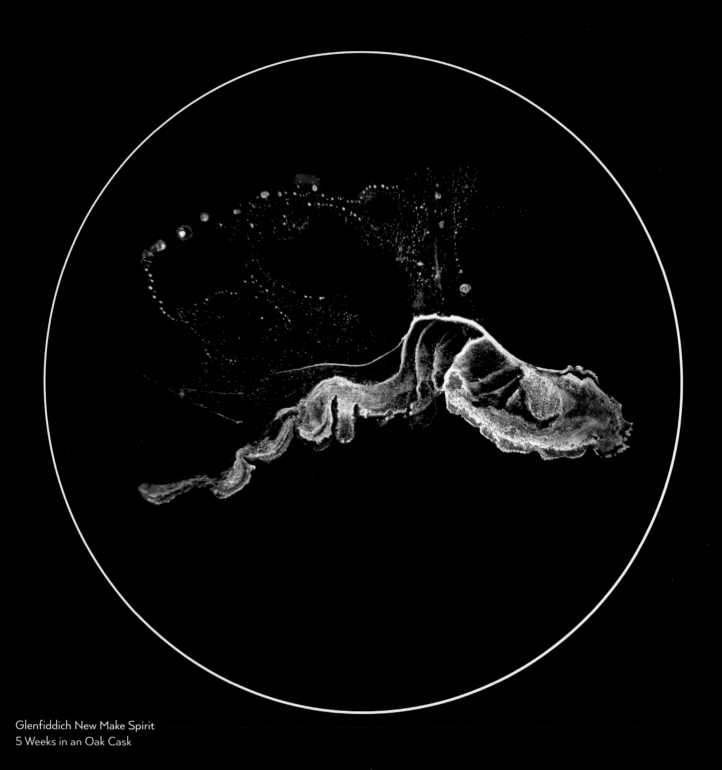

Glenfiddich New Make Spirit
5 Weeks in an Oak Cask

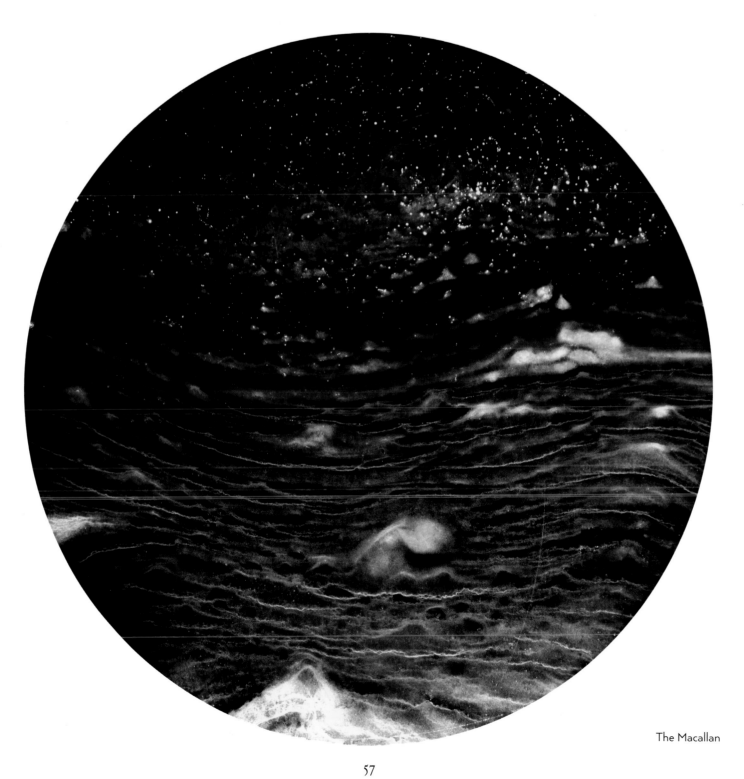

The Macallan

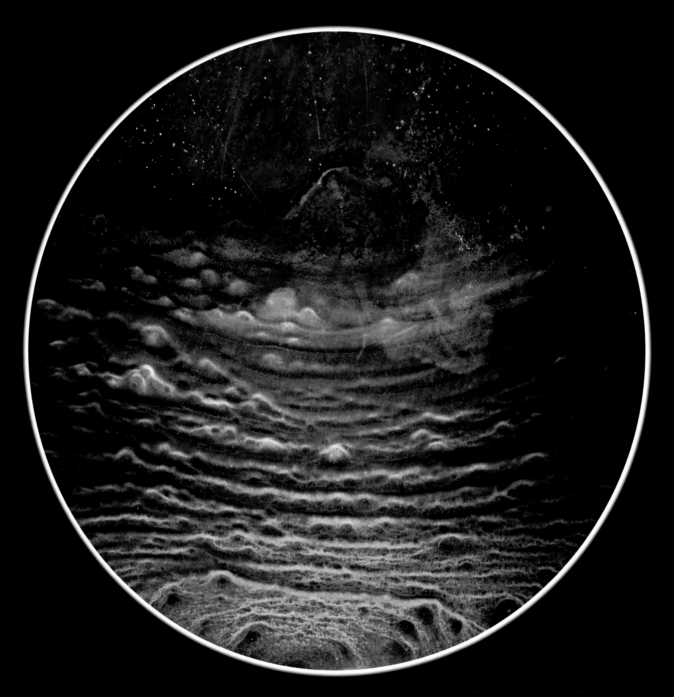

The Balvenie Doublewood 17 YO

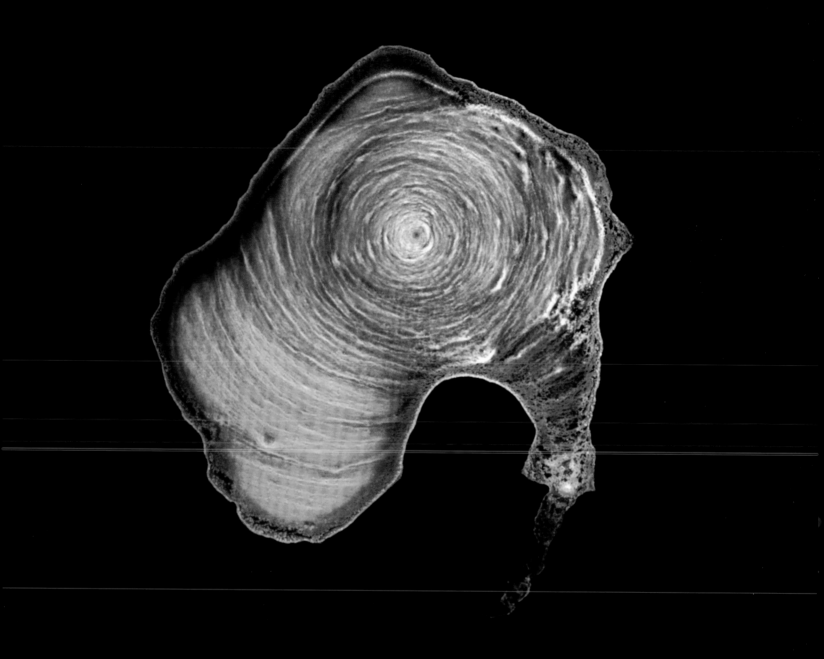

Glenfiddich Experimental Cask

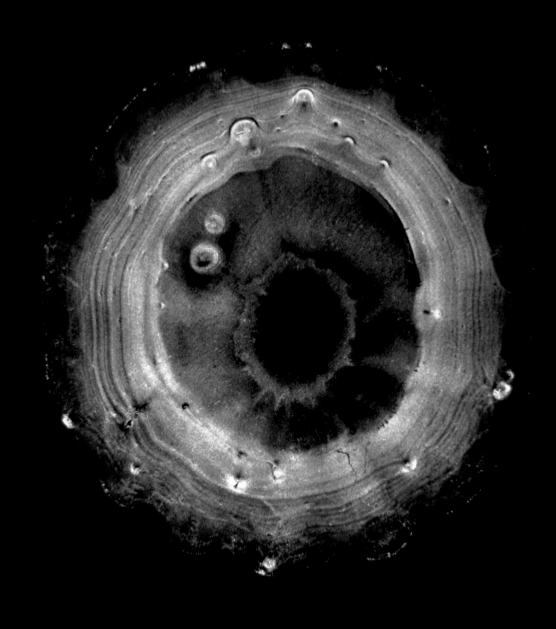

Glenfiddich Experimental Cask

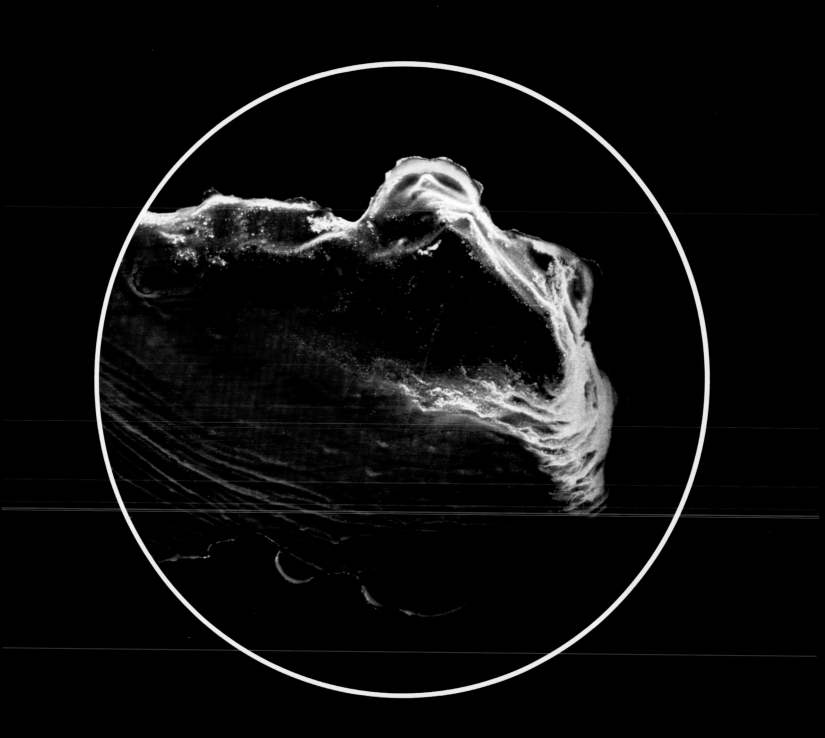

Glenfiddich New Make Spirit
5 Weeks in an Oak Cask

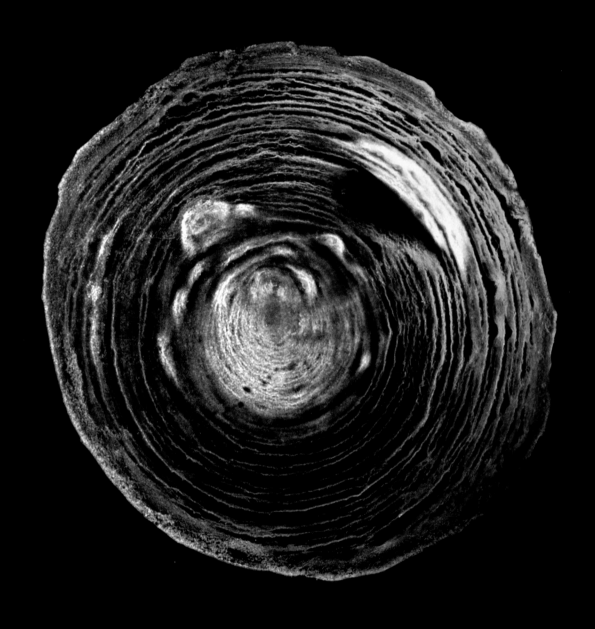

Glen Moray 18 YO

# TASTING NOTES

**COLOR:** Antique gold.

**NOSE:** Full of creamy fruit: melon, apricot, and peach soaked in a brandy butter sauce. Underlying citrus aromas come through, revealing Seville oranges and lemons. Sweetness continues with buttered toffee popcorn. A faint suggestion of wood spice hints at cinnamon and anise to complete a sumptuous bouquet.

**TASTE:** A beautifully complex flavor of heather honey and a warming wood spice combined with a thick, velvety mouthfeel allows this whisky to coat the palate with characters of cherry and hazelnut. A seductive hit of full-fat cream and white chocolate–coated raspberry infused with ginger follows.

**FINISH:** The finale is dominated by the wood spice and citrus flavors combining to create a long lingering taste of clove-studded oranges and a gentle fading of fresh vanilla pods. A finish to be savored and never forgotten.

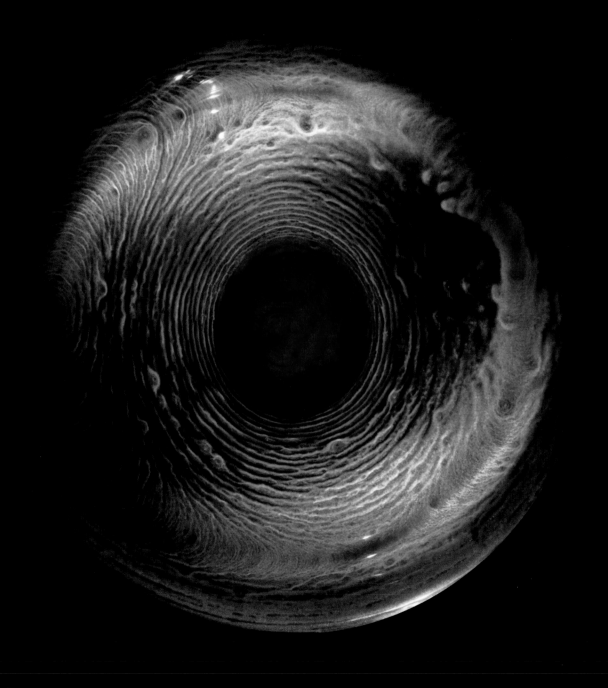

Glenfiddich XX

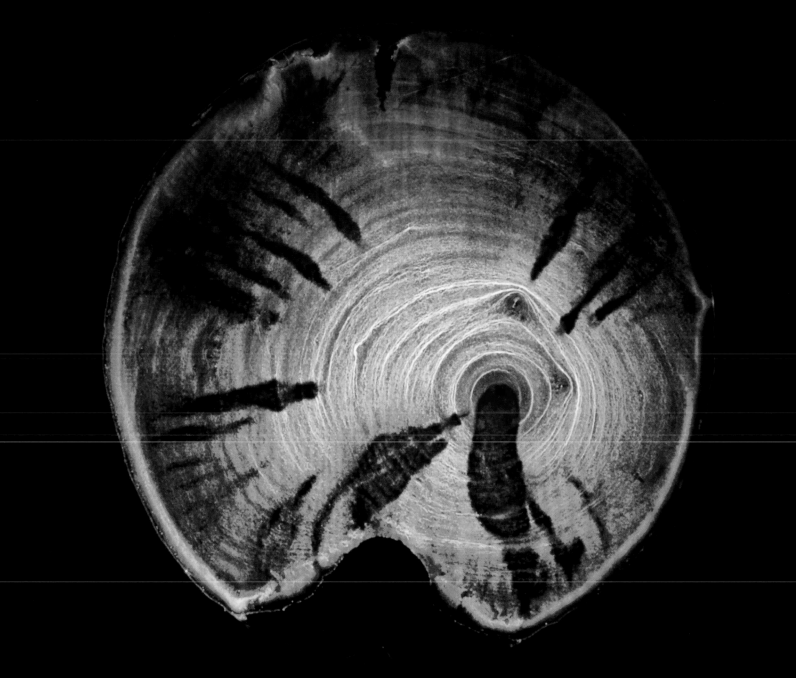

Glenfiddich Fire & Cane

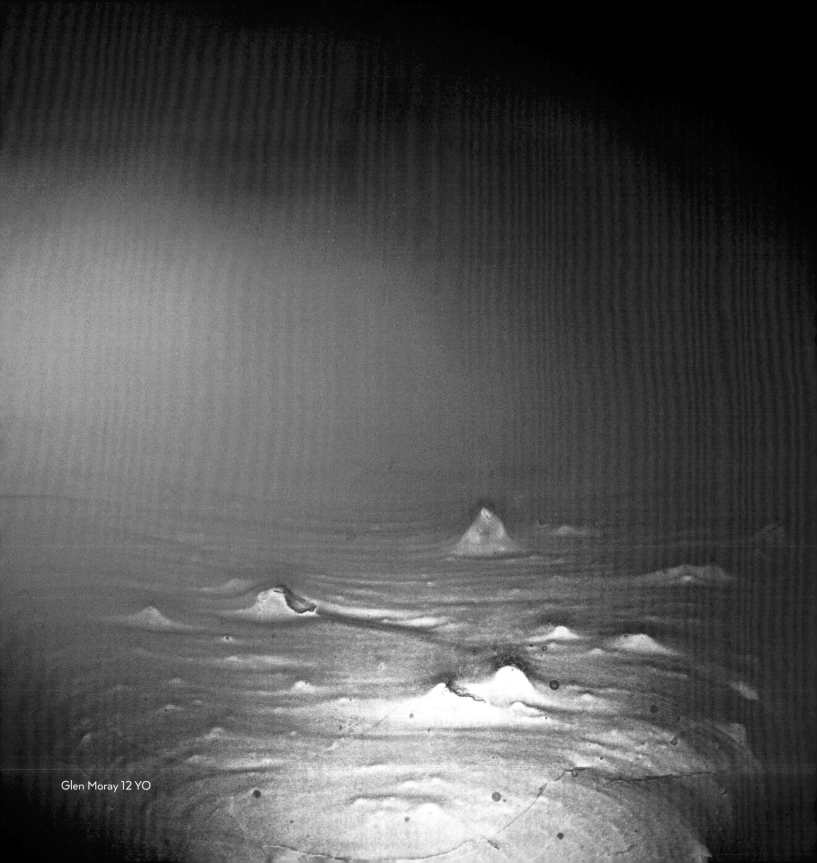

Glen Moray 12 YO

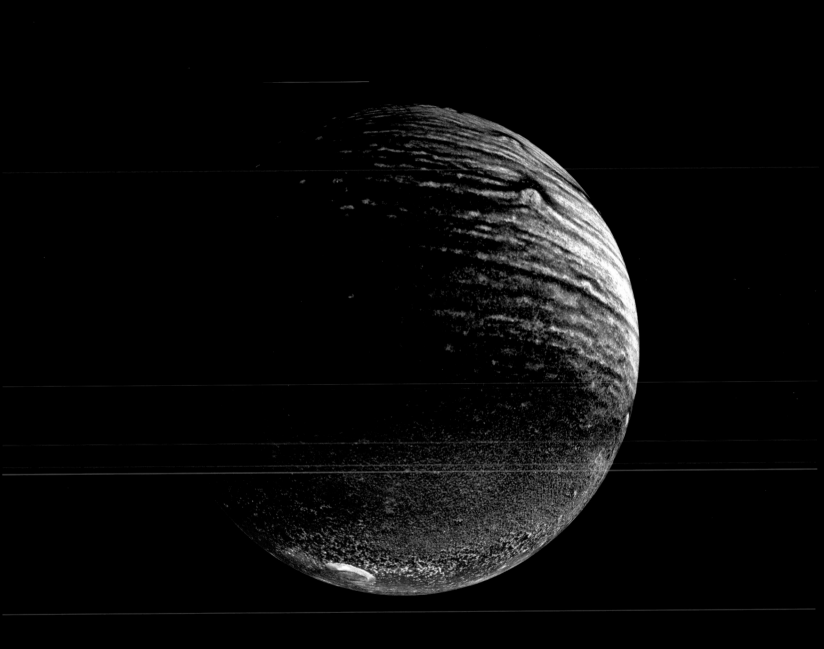

Planet Winter Storm

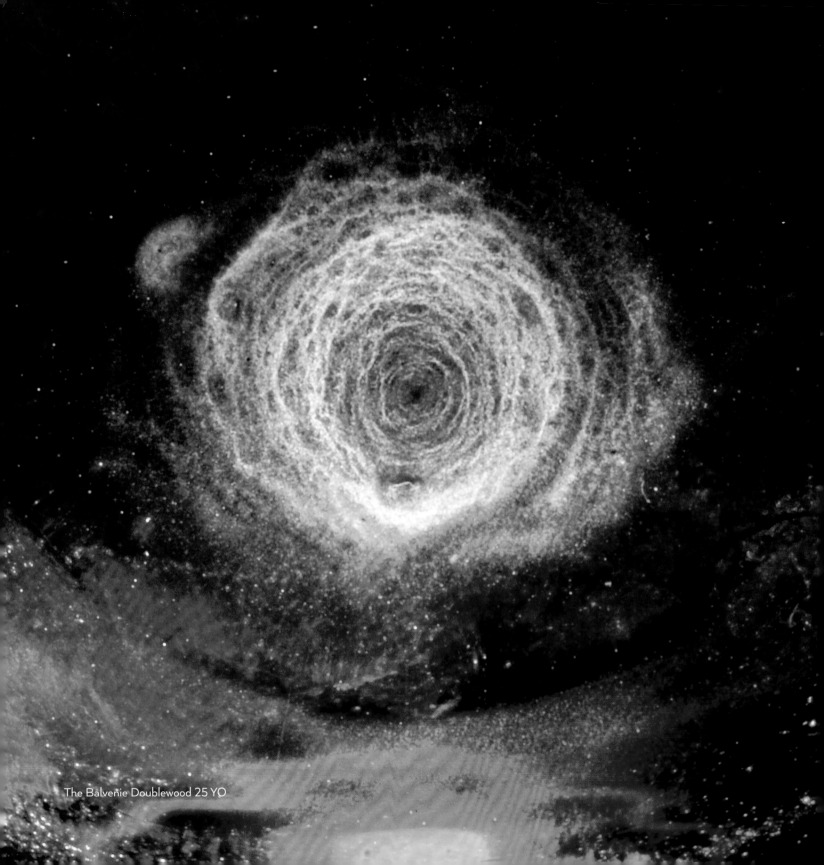

The Balvenie Doublewood 25 YO

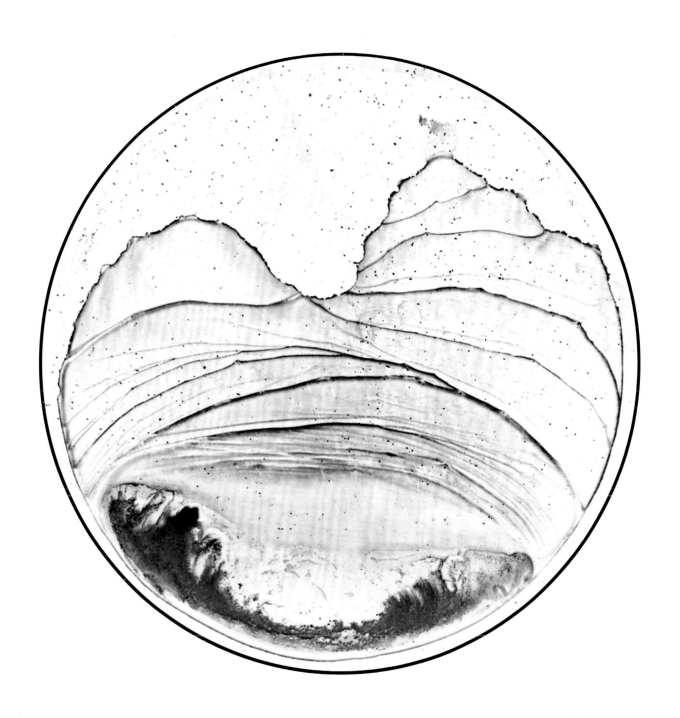

Glenfiddich New Make Spirit
5 Weeks in an Oak Cask

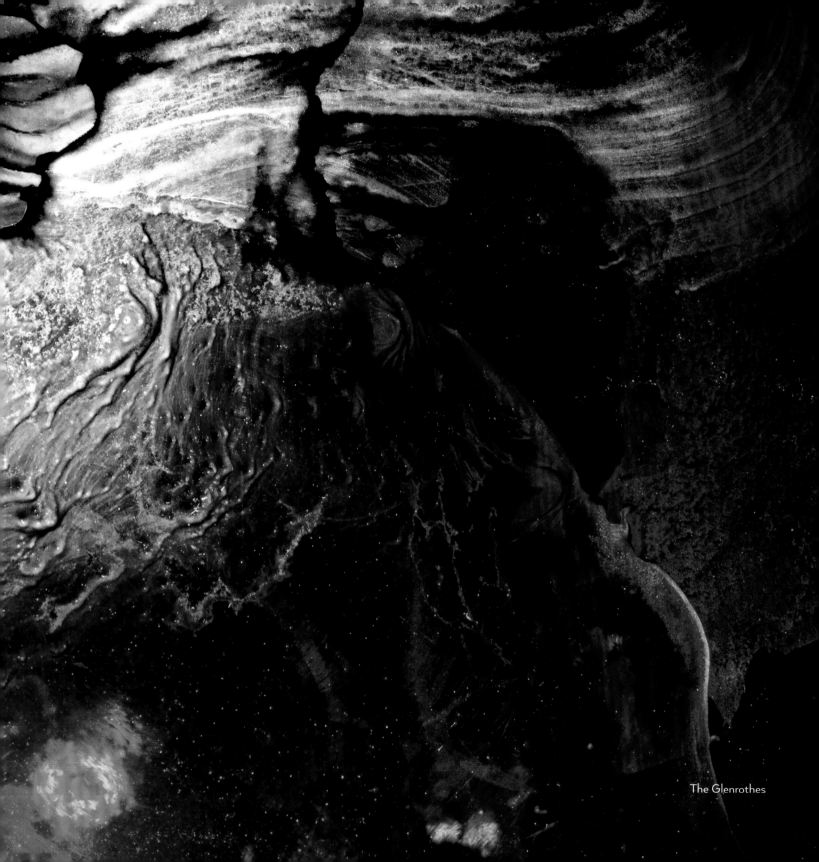

The Glenrothes

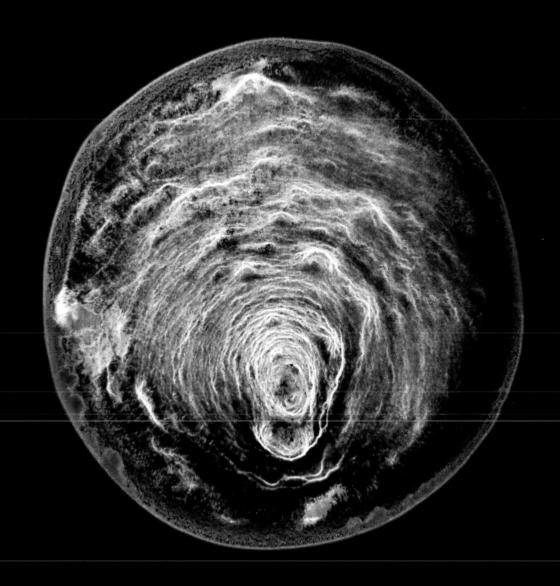

Glenfiddich Experimental Cask

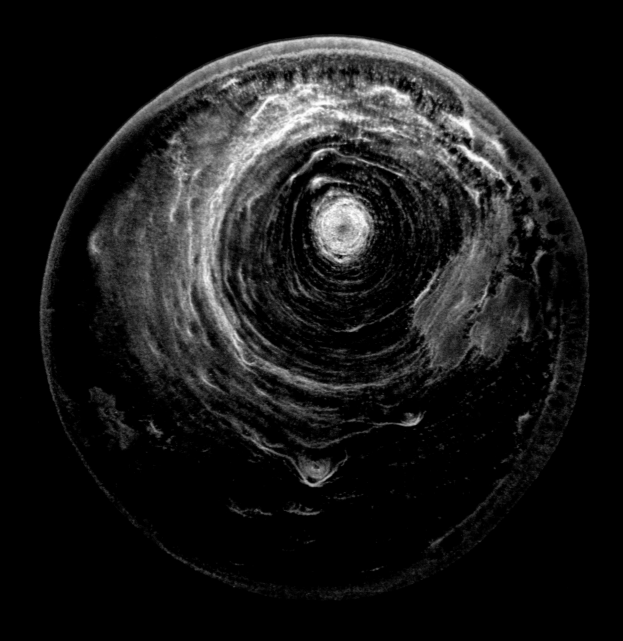

Glenfiddich Experimental Cask

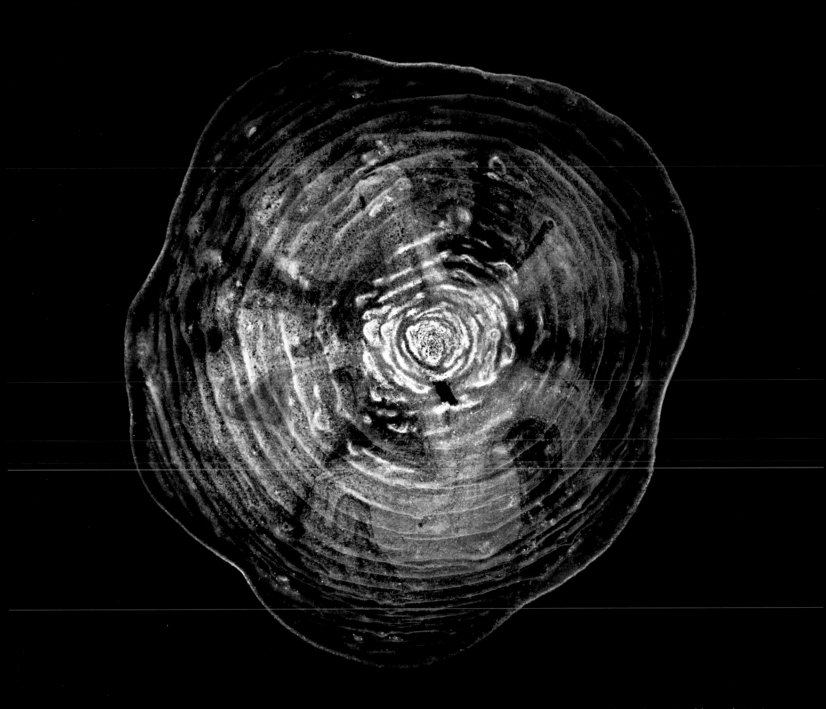

The Balvenie Doublewood 12 YO

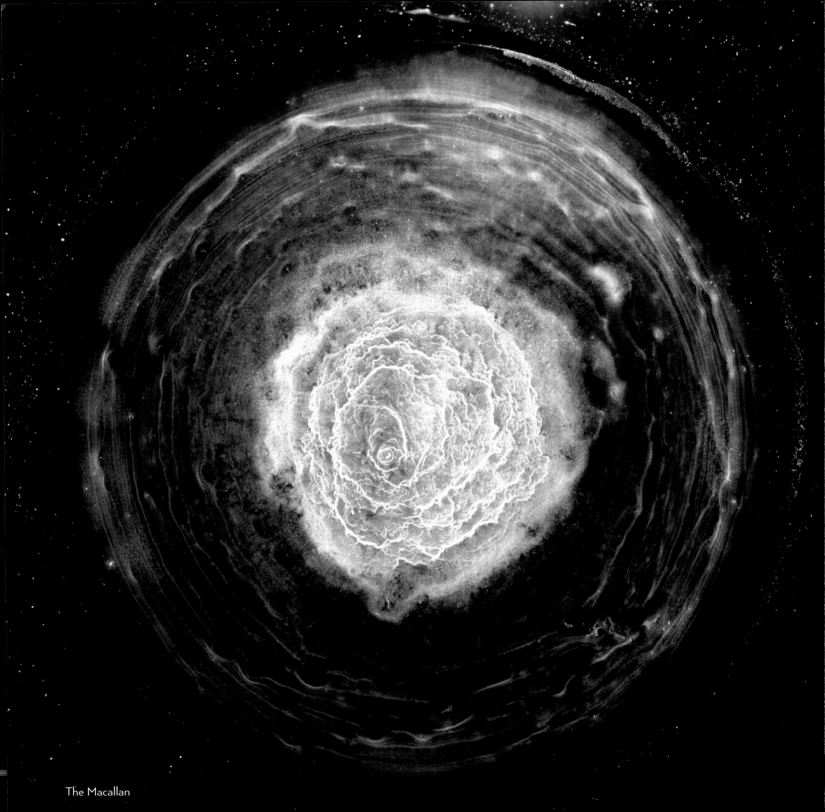

The Macallan

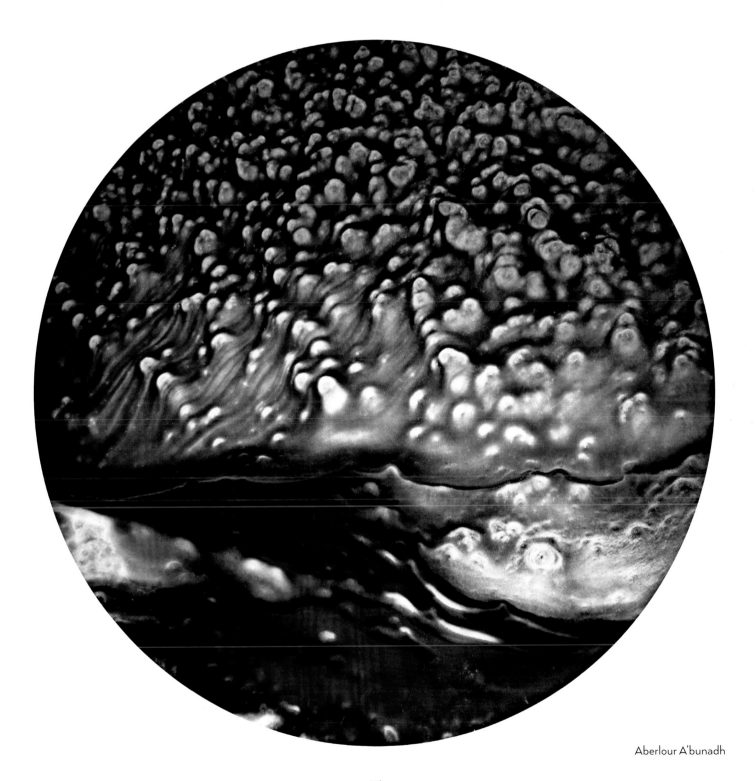

Aberlour A'bunadh

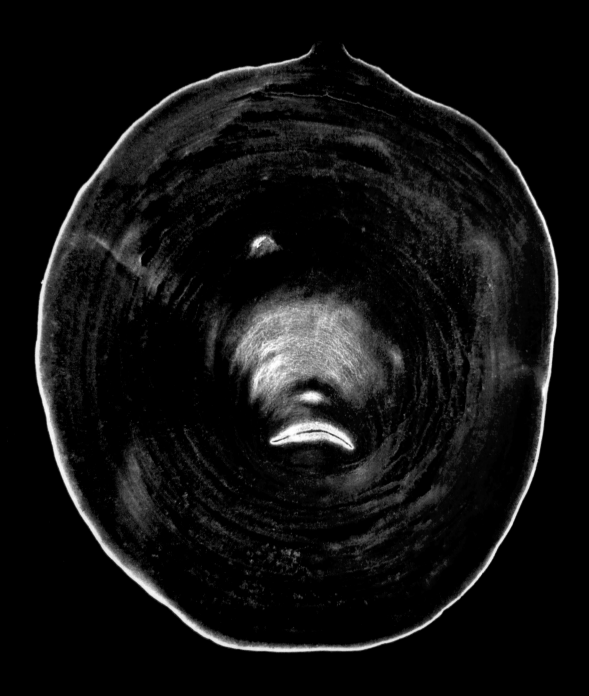

The Balvenie Doublewood 12 YO

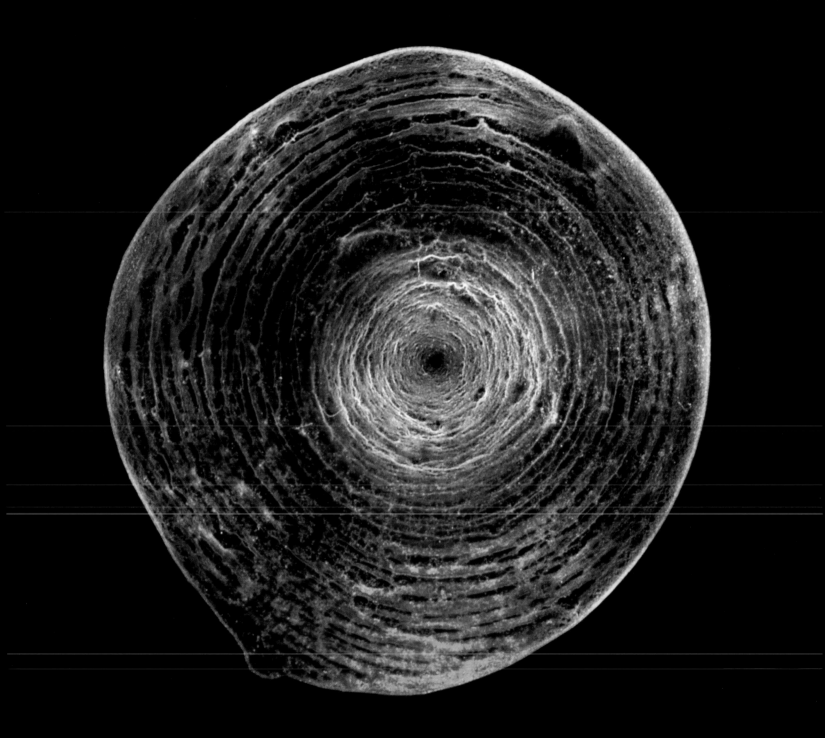

Glenfiddich IPA

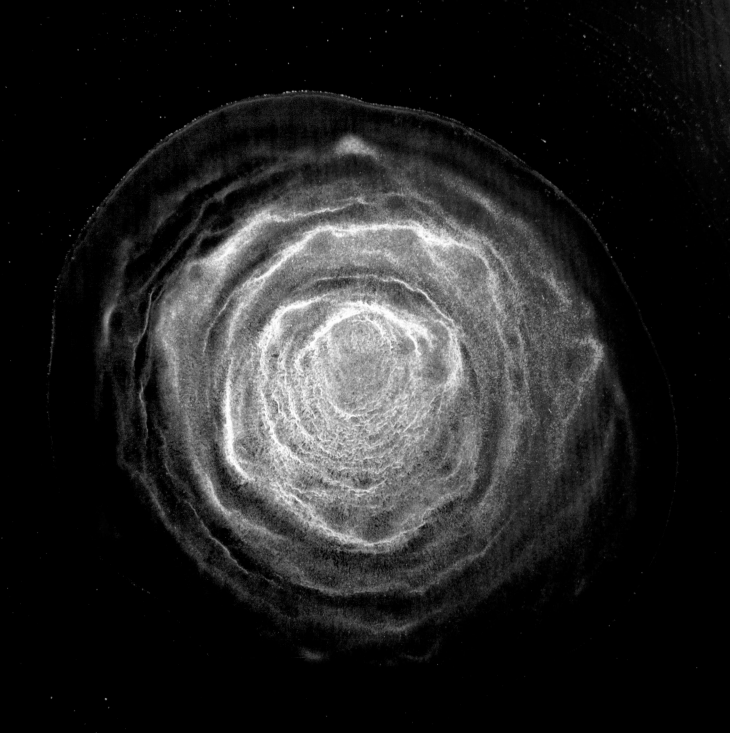

The Macallan

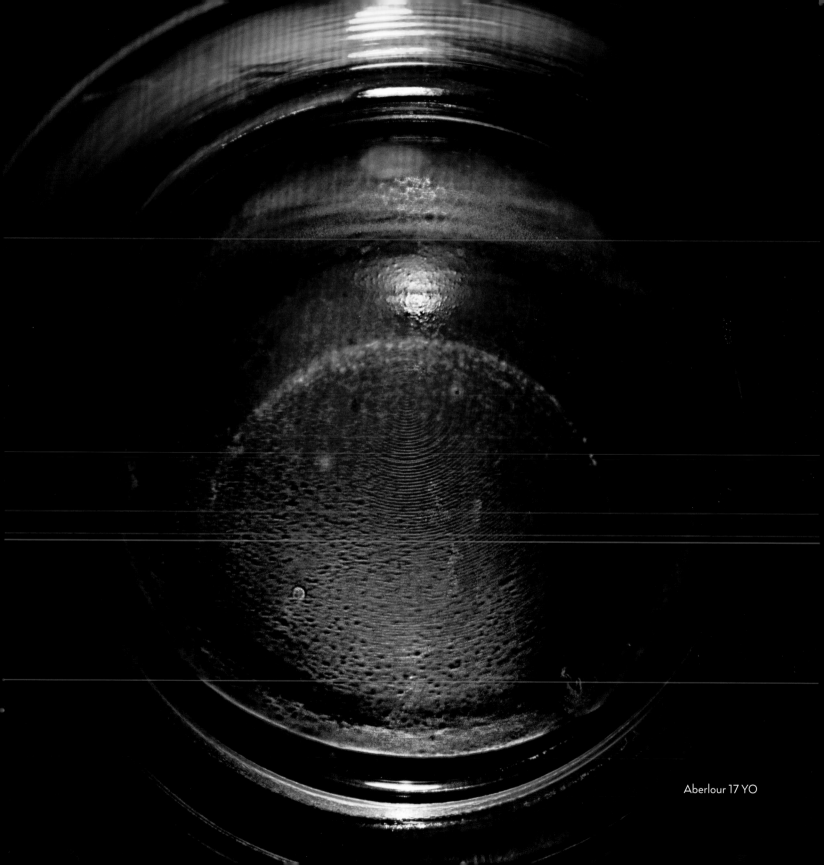

Aberlour 17 YO

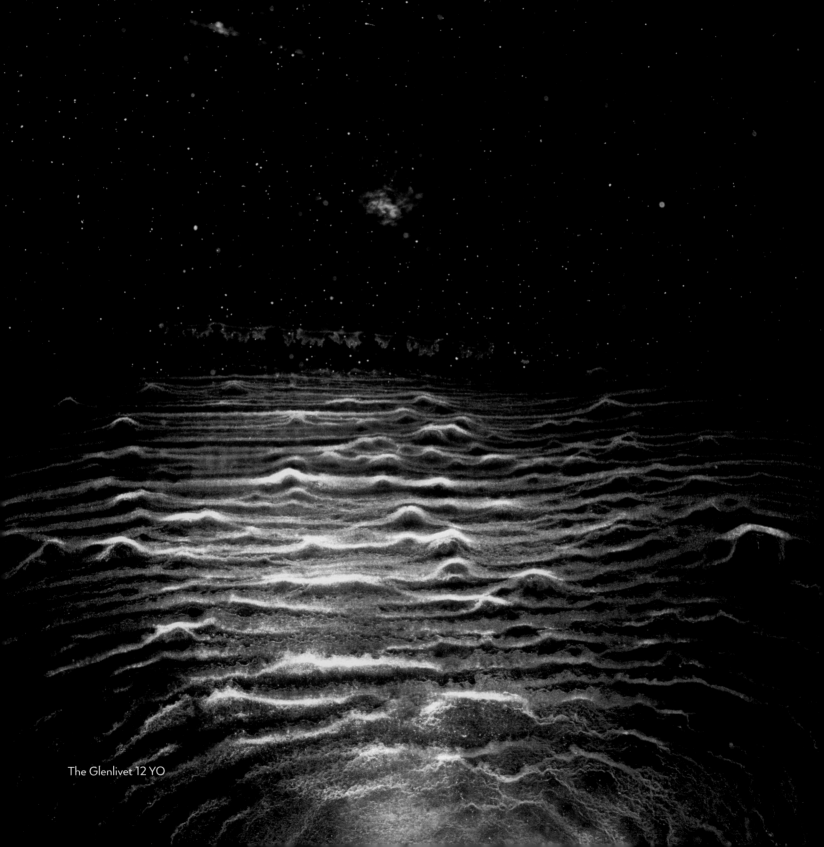

The Glenlivet 12 YO

## TASTING NOTES

**NOSE:** Vibrant aromas of summer meadows and tropical fruits, notably pineapple.

**PALATE:** Floral notes, smooth and sweet fruit notes of fresh peaches and pears, vanilla.

**FINISH:** Marzipan and fresh hazelnuts.

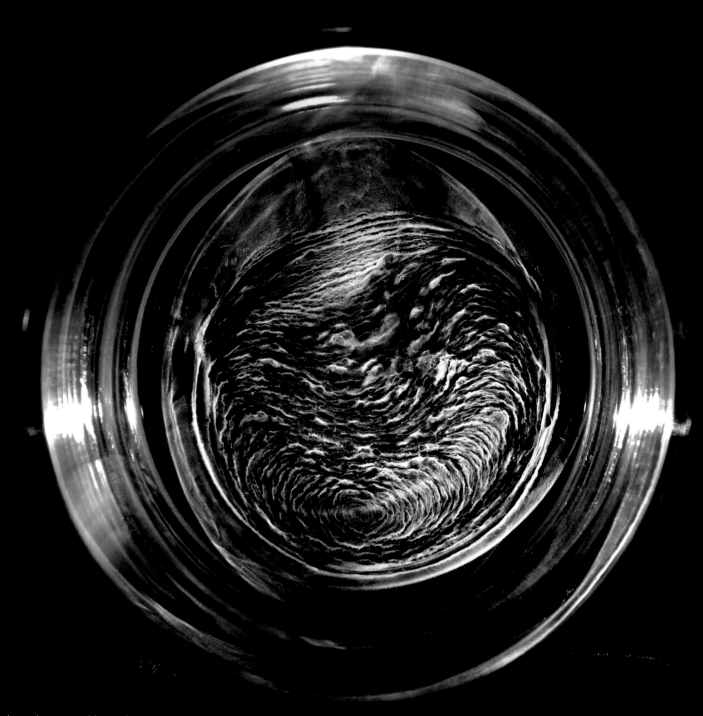

The Balvenie Doublewood 17 YO

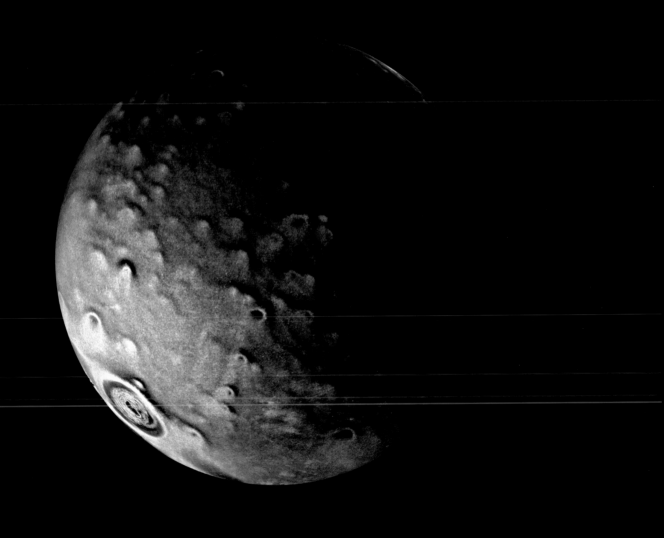

Planet Macallan

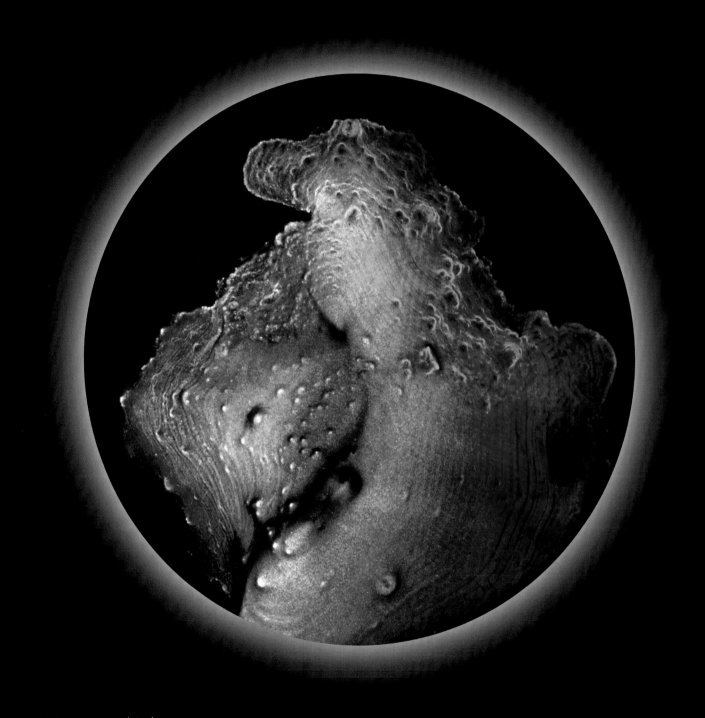

Glenfiddich Experimental Cask

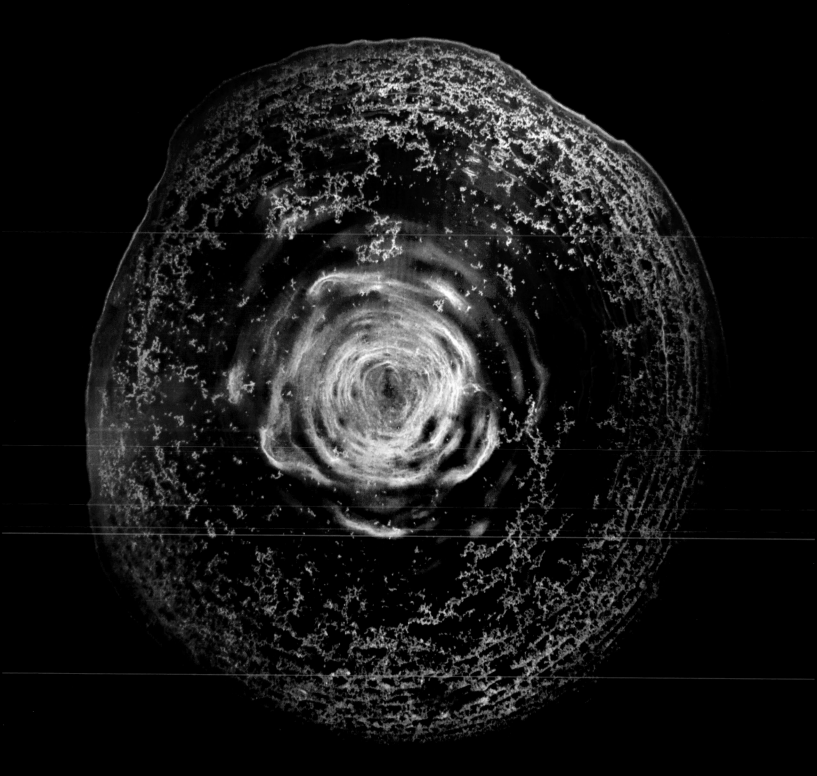

The Macallan

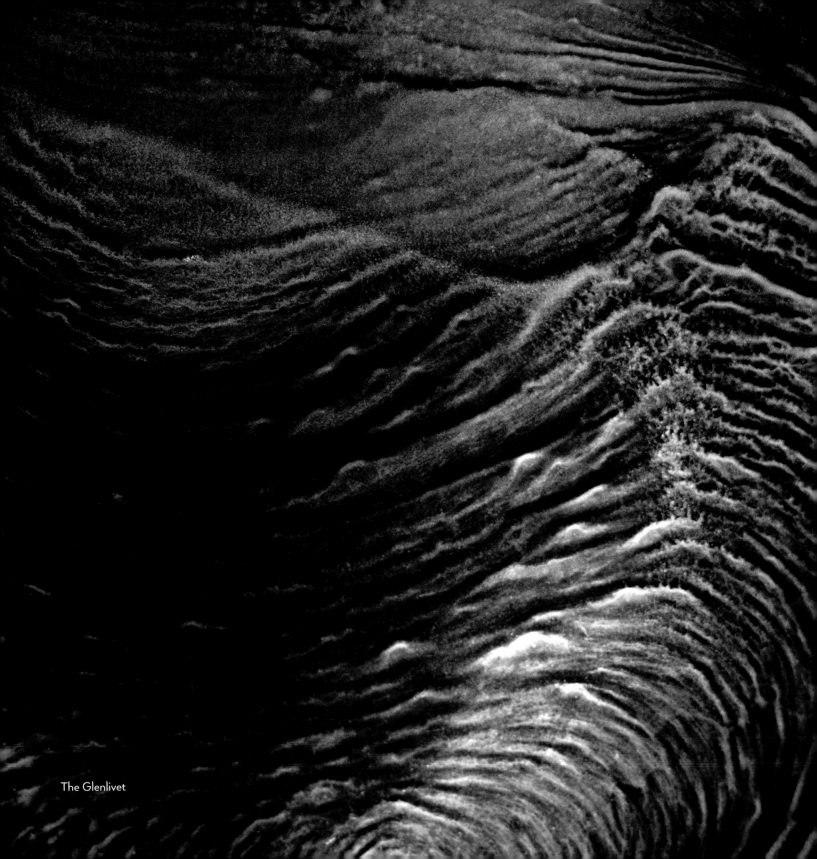

The Glenlivet

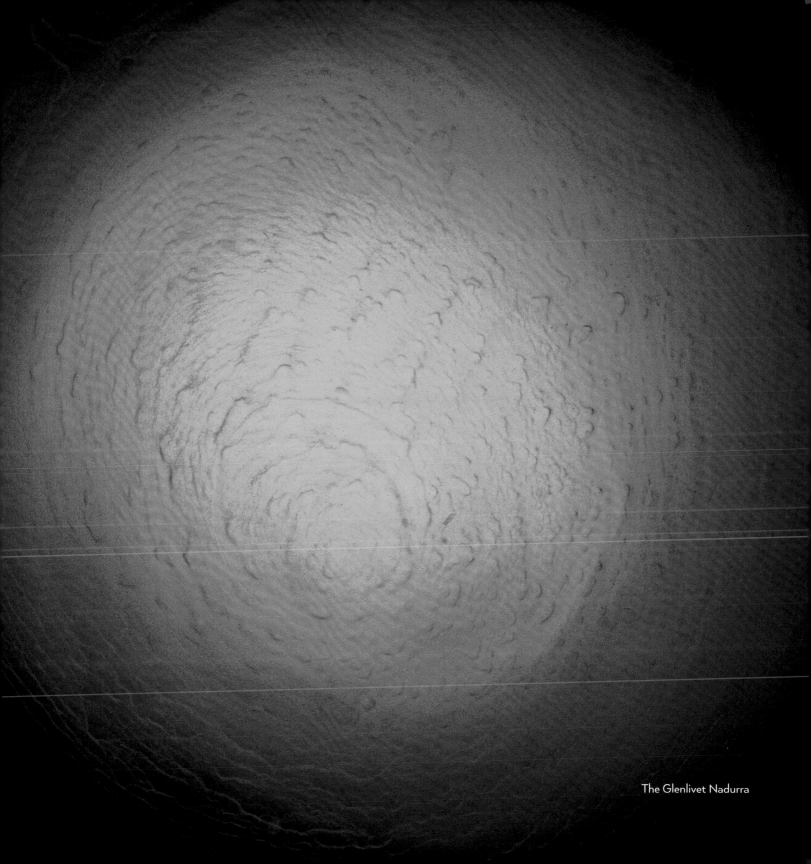

The Glenlivet Nadurra

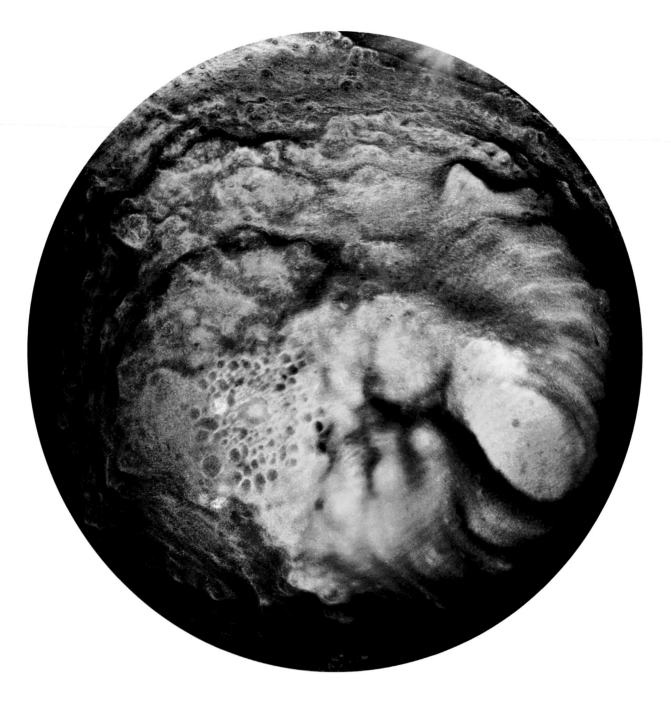

Aberlour A'bunadh

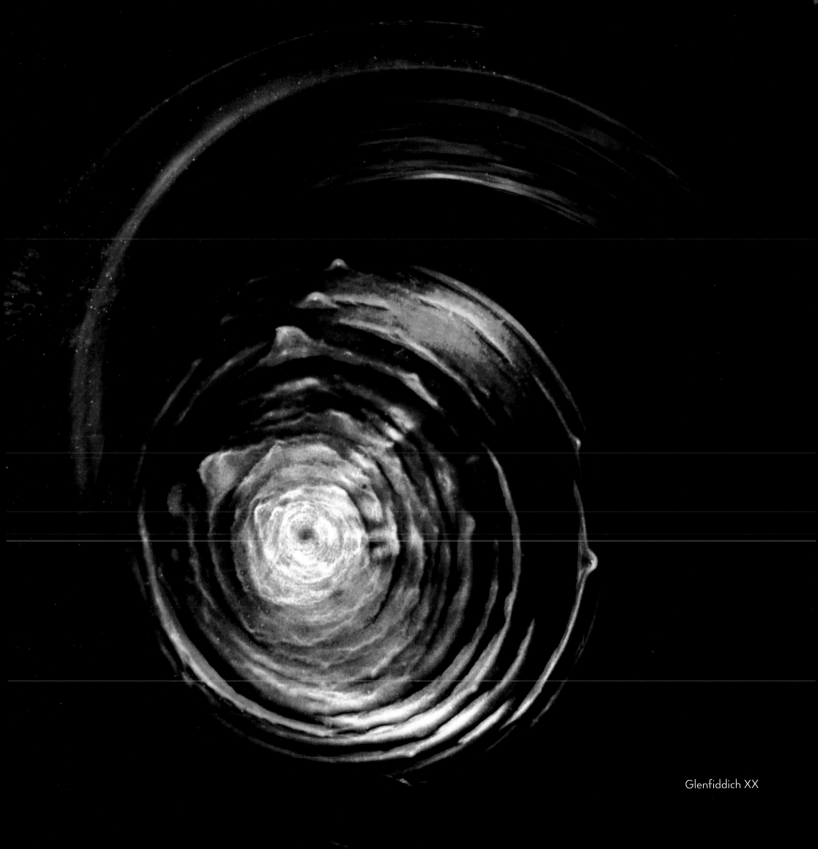

Glenfiddich XX

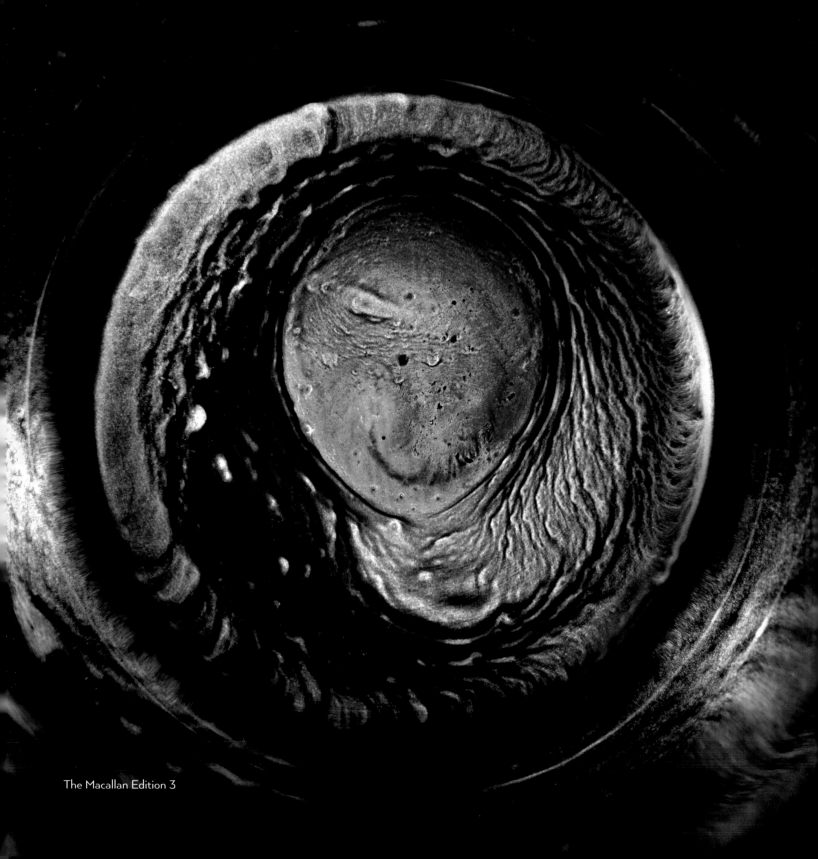

The Macallan Edition 3

# TASTING NOTES

**COLOR:** Barley gold.

**NOSE:** Reminiscent of a fine fragrance with vanilla ice cream, fresh cut oak, and delicate florals. Orange oil provides subtle grandeur while ginger, cinnamon, and nutmeg flit in and out. Vanilla imparts sweetness with citrus fruits at the fore before allowing chocolate to come through. Burnished oak delivers a soft ending.

**PALATE:** Sweet fruit, vanilla, and rich fruit cake with hints of apricot, pear, and crisp green apple. Ginger and cinnamon are balanced with a light resinous oak finale.

**FINISH:** Long, sweet, and fruity, leaving a lasting impression on the senses.

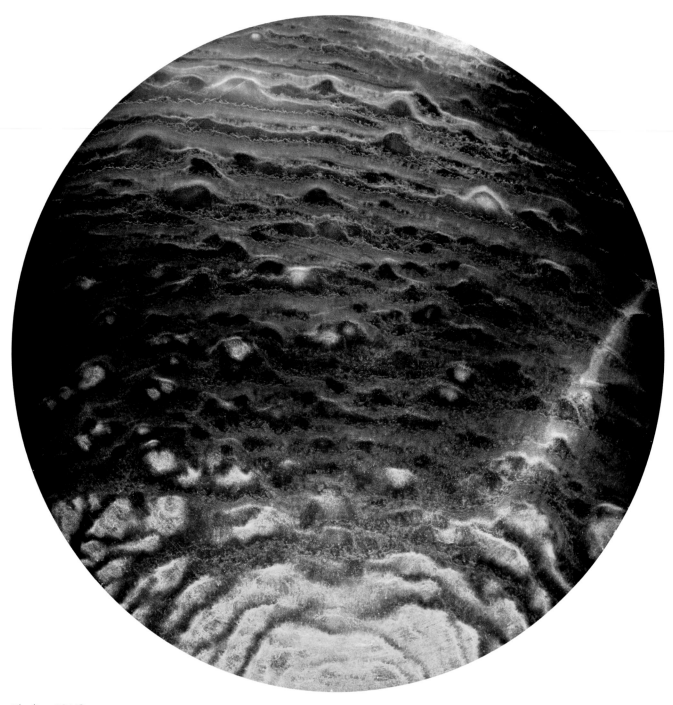

The Glenlivet 12 YO

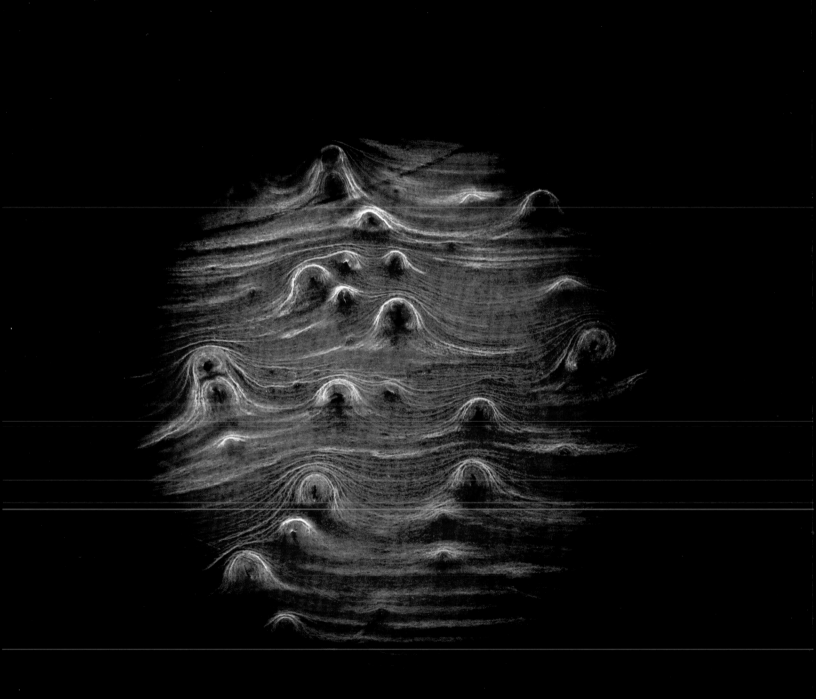

Glenfiddich XX

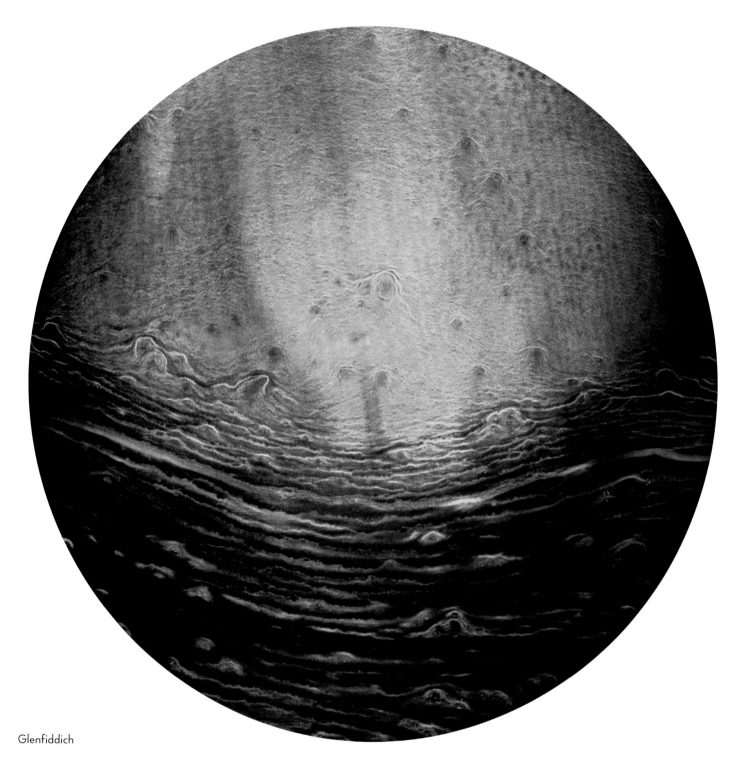

Glenfiddich

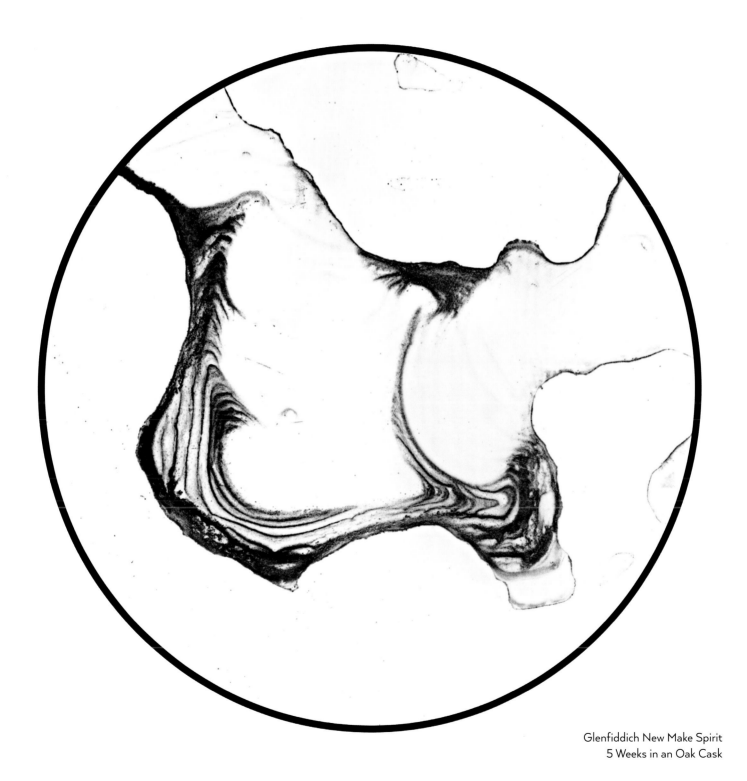

Glenfiddich New Make Spirit
5 Weeks in an Oak Cask

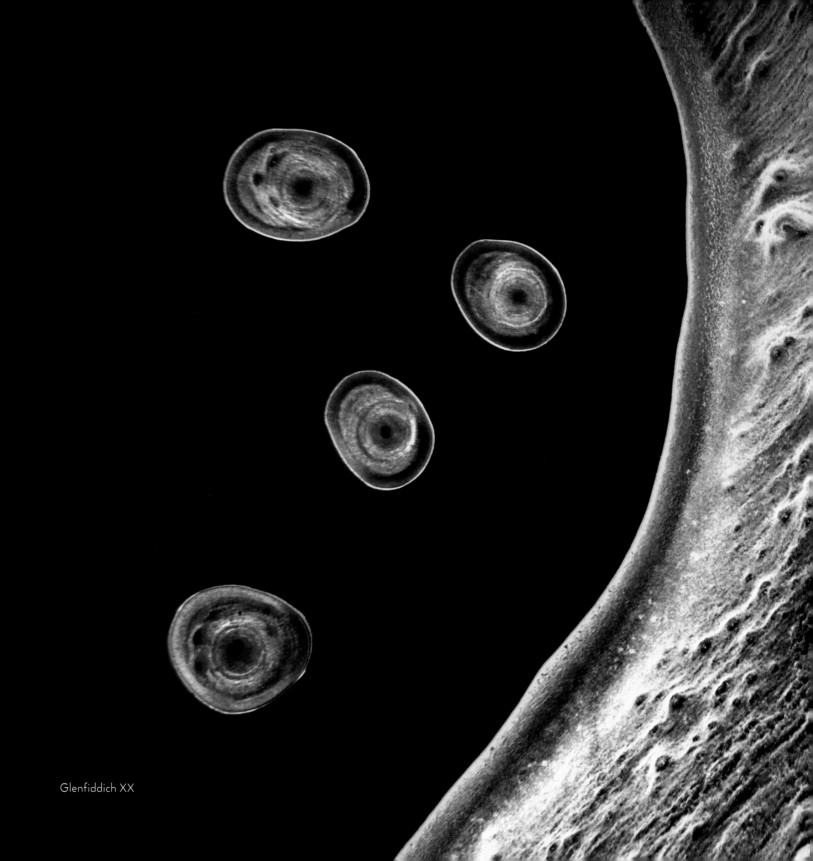

Glenfiddich XX

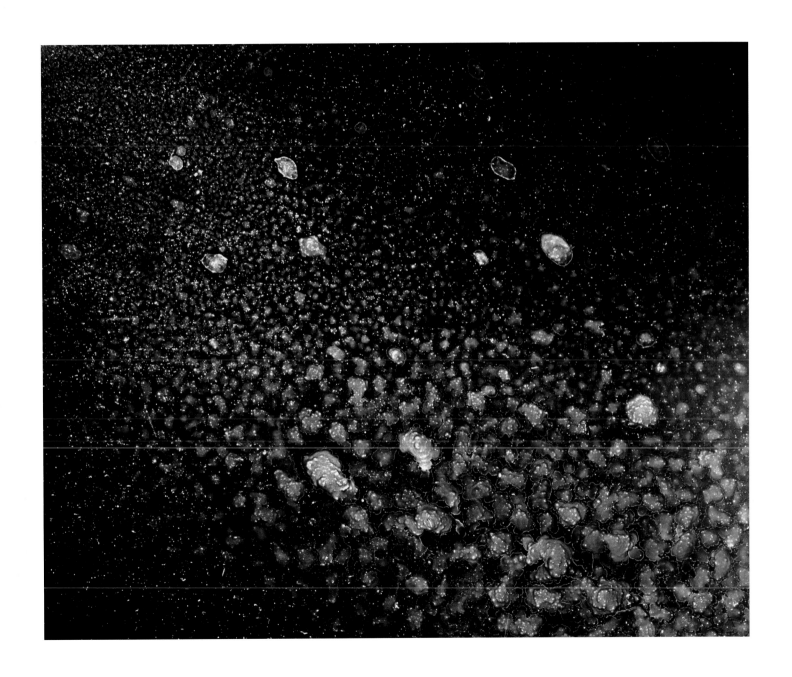

Glenfiddich IPA

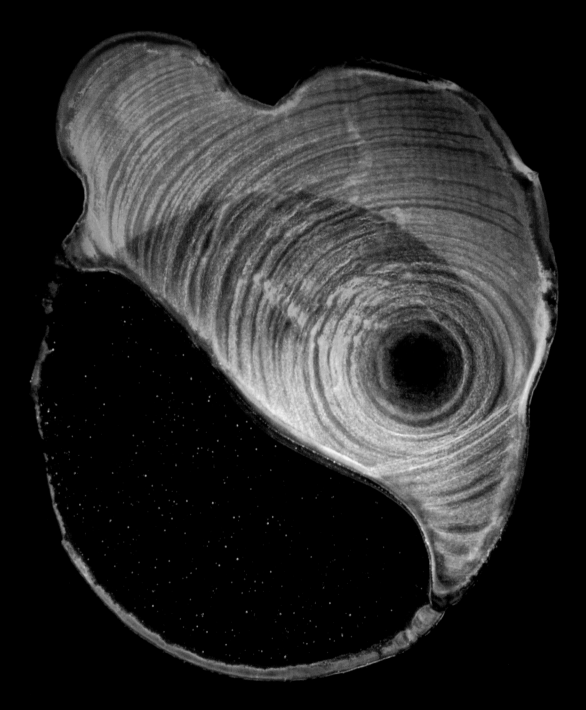

Glenfiddich Fire & Cane

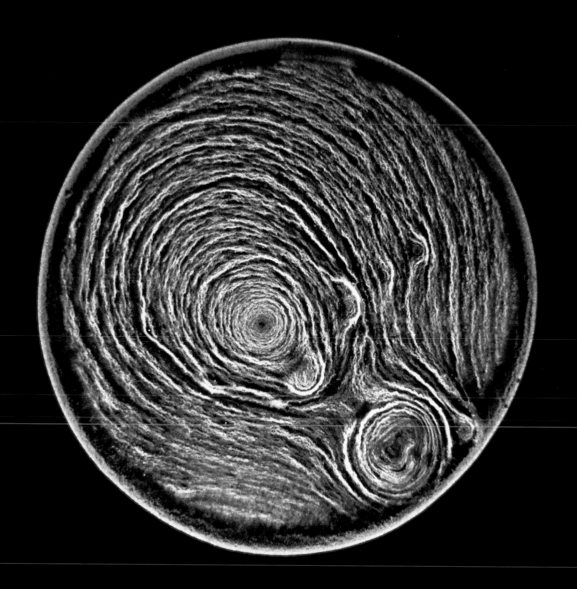

Glenfiddich XX

# HIGHLAND

## The Highland Malts

THE SCOTTISH HIGHLANDS ARE THINLY POPULATED, wild, and dramatic: a land of mountains and lochs (lakes), sundered from the Lowlands by language, custom, and tradition, as much as by geography. However, today most of the "Highland" distilleries are located in the fertile lowlands of the east coast, with some scattered across the islands to the north and west.

This is the largest whisky region and its vast spread leads to a wide diversity of flavors. Historically, the feature that differentiated Highland whiskies from those made in the Lowlands was the use of peat to dry the malt, bestowing degrees of smokiness. This is less apparent today, except in malts from the West Highlands. Some makes, from both the west and the northeast, are distinctly maritime (briny, seaweed, boat varnish) and spicy (chili, white and black pepper); others are honeyed (some even waxy), herbal, mossy, meaty, and malty, with notes of vanilla and coconut.

They are generally sweet (but not as sweet as Speysides), with a dry finish.

—C. M.

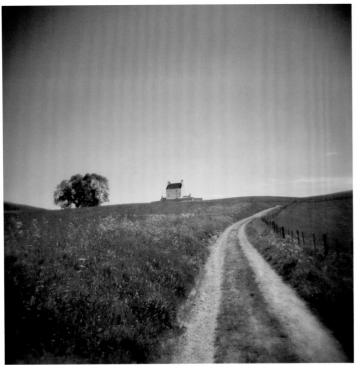

Corgarff Castle

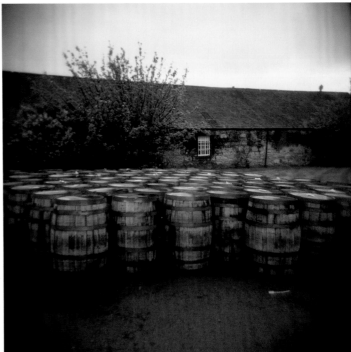

Barrels at Glenmorangie

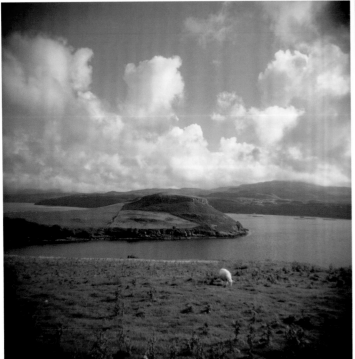

The Isle of Skye

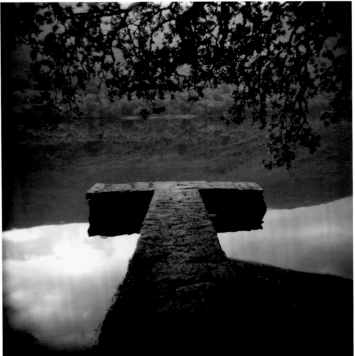

Loch Oich near Glengary Castle

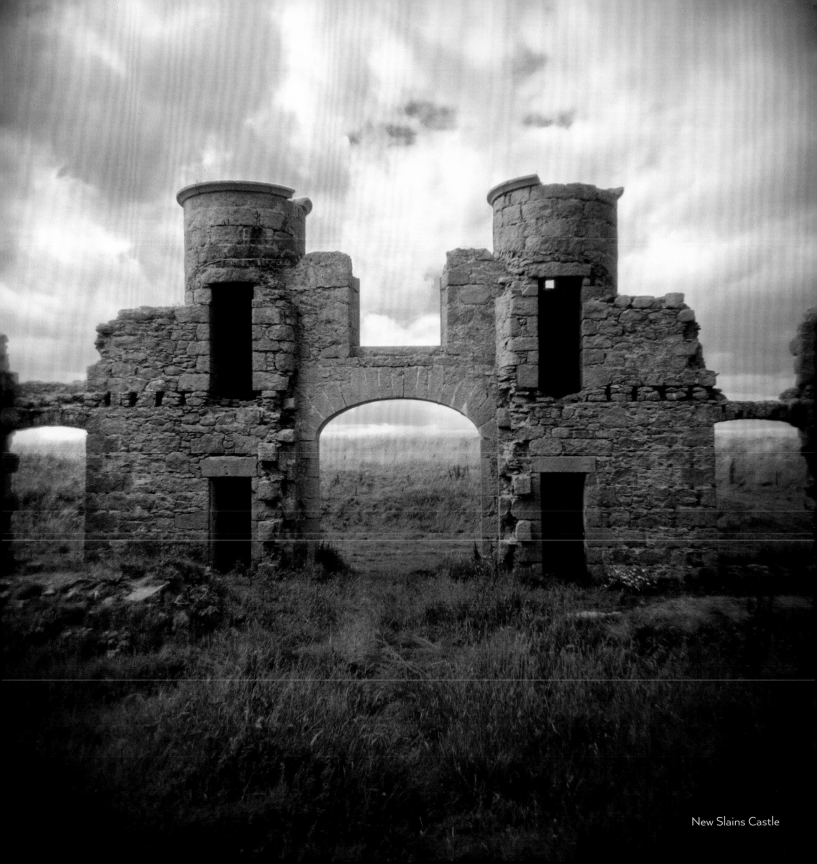

New Slains Castle

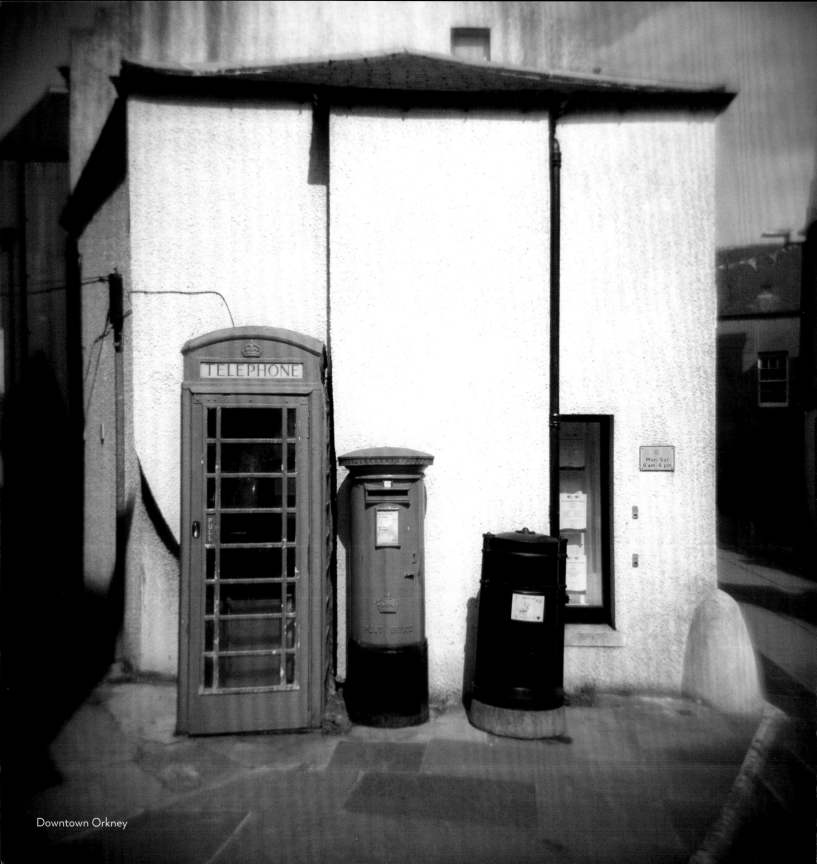

Downtown Orkney

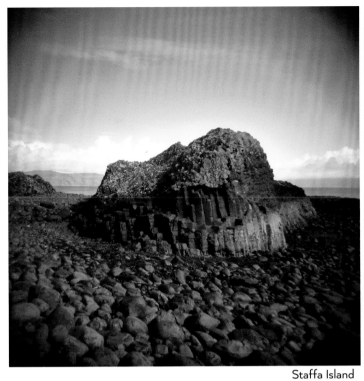

Staffa Island

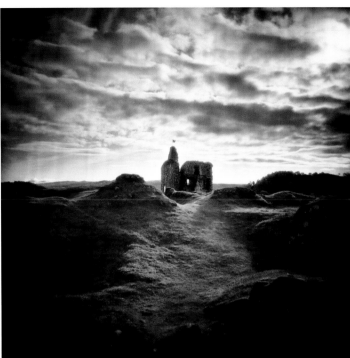

Tarbert Castle

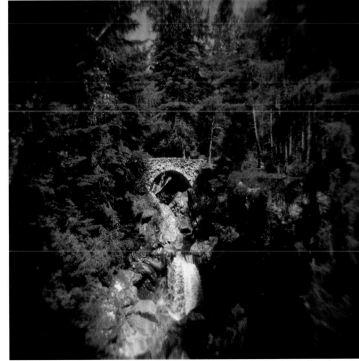

The Falls of Bruar

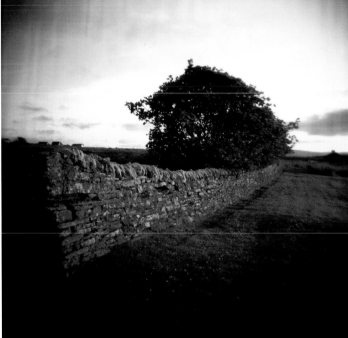

Orkney Sunsets

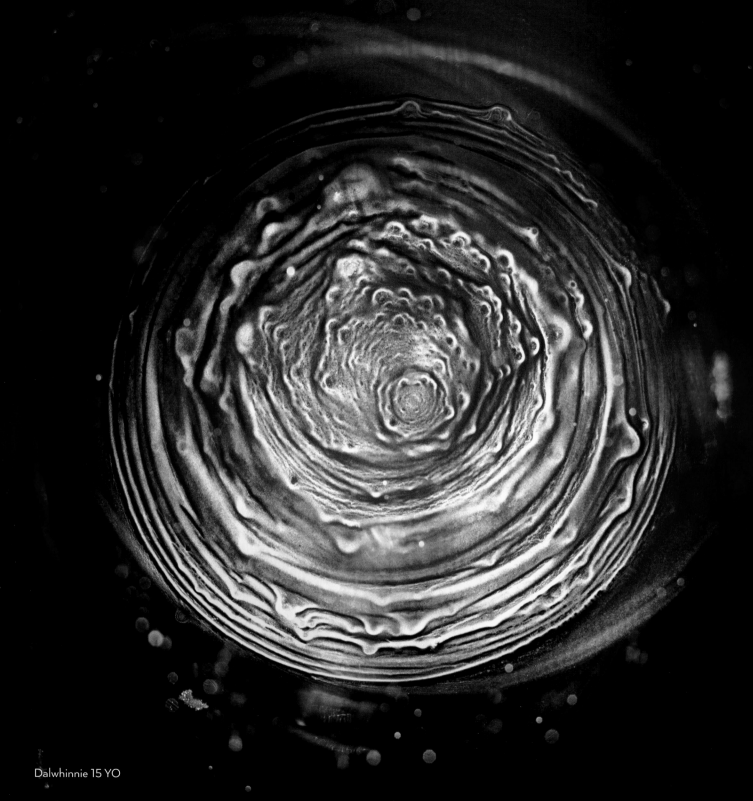

Dalwhinnie 15 YO

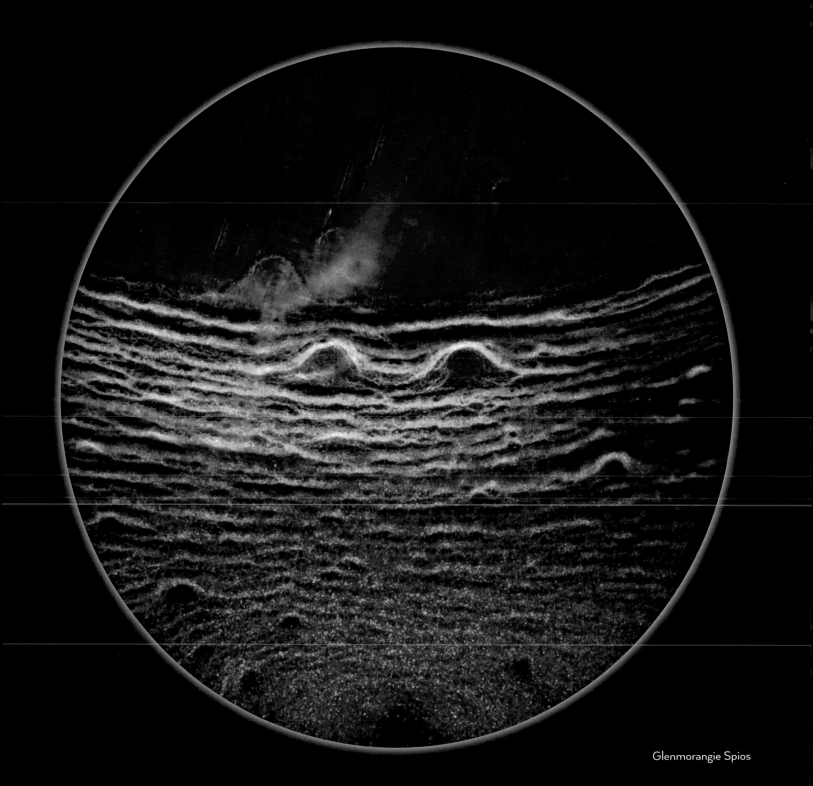

Glenmorangie Spios

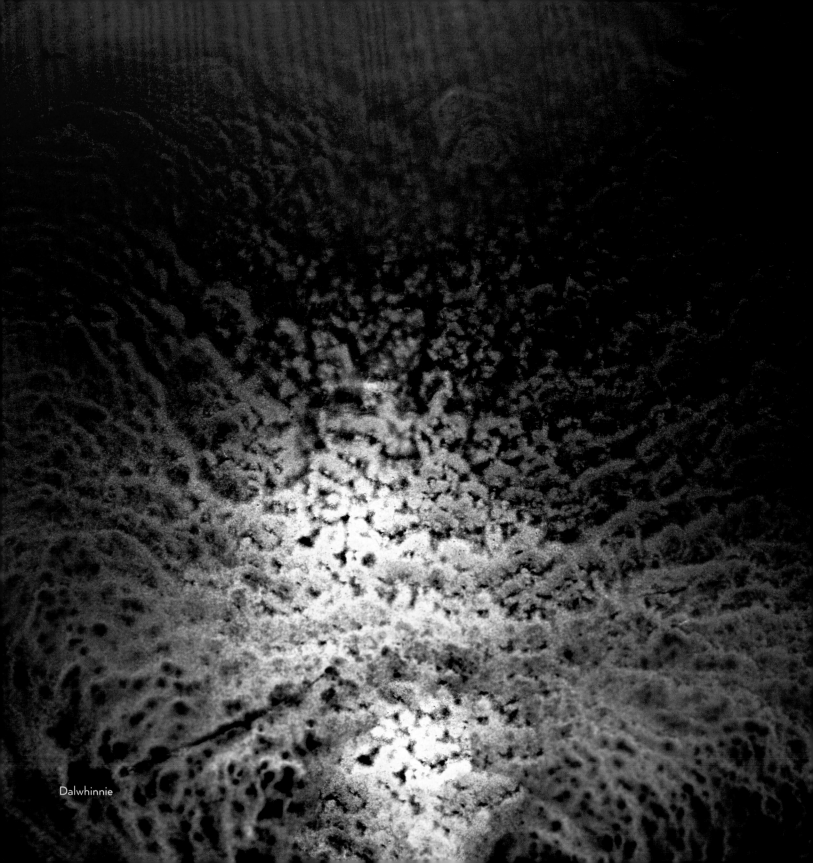

Dalwhinnie

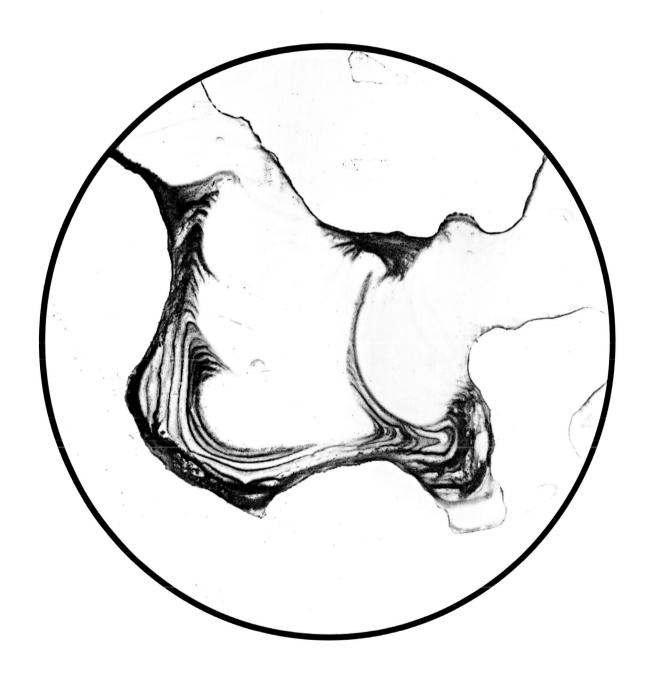

Clynelish 14 YO

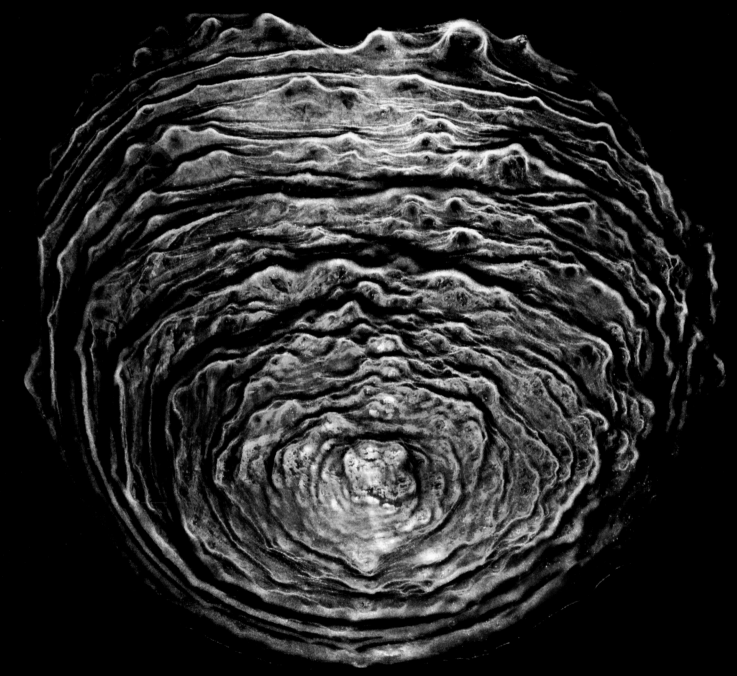

Glenmorangie Tusail

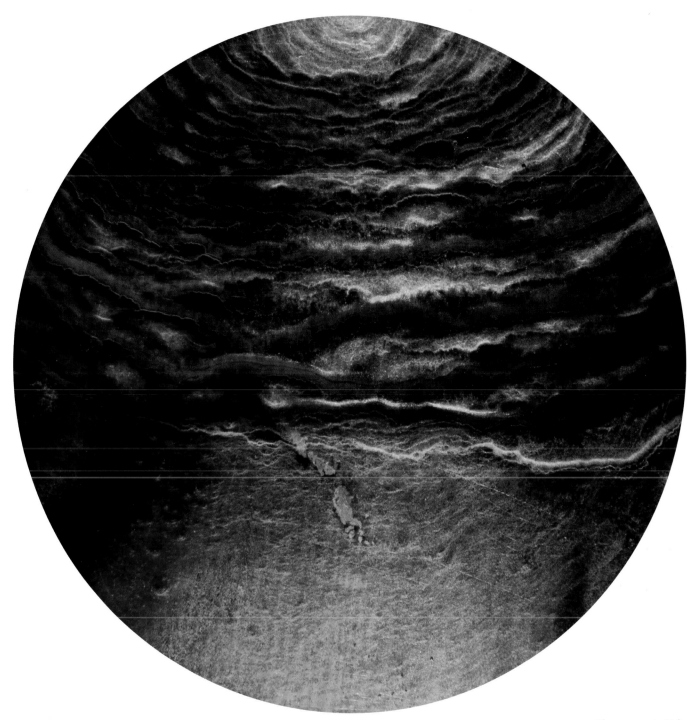

Glenmorangie Ealanta

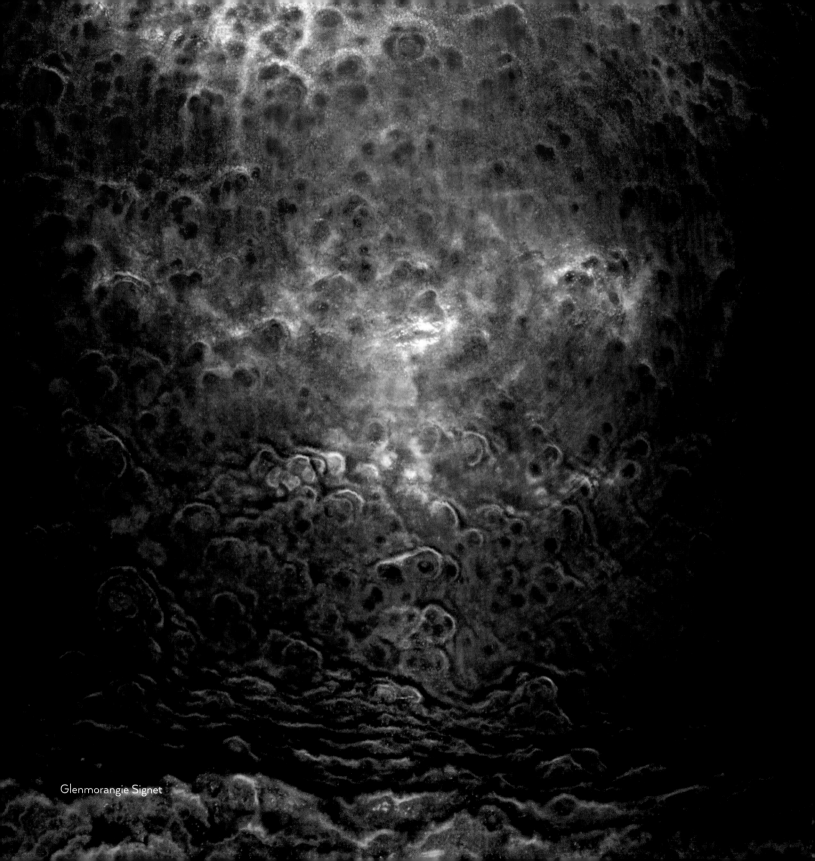

Glenmorangie Signet

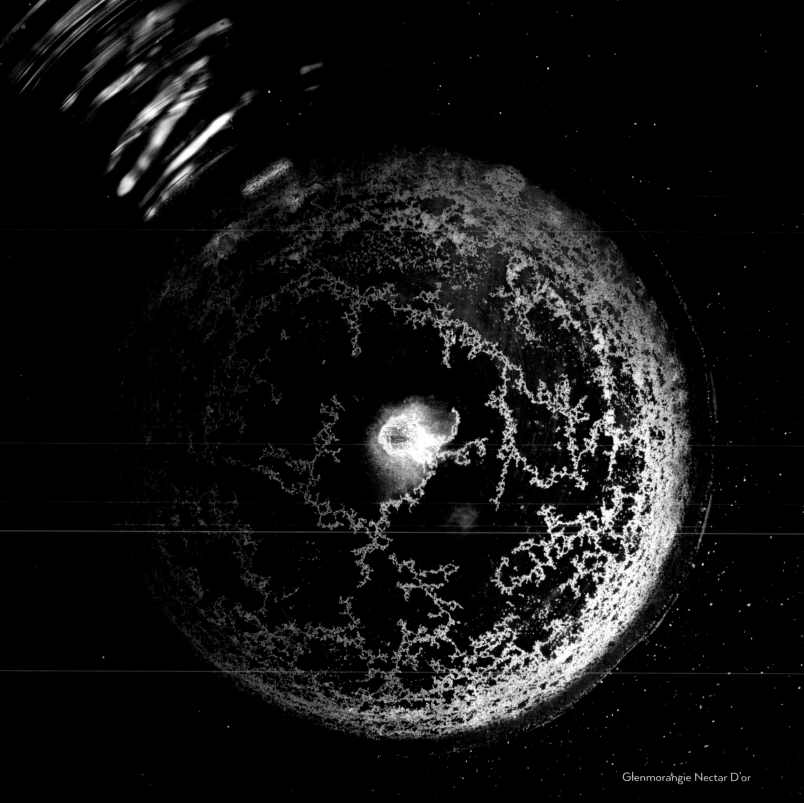

Glenmorangie Nectar D'or

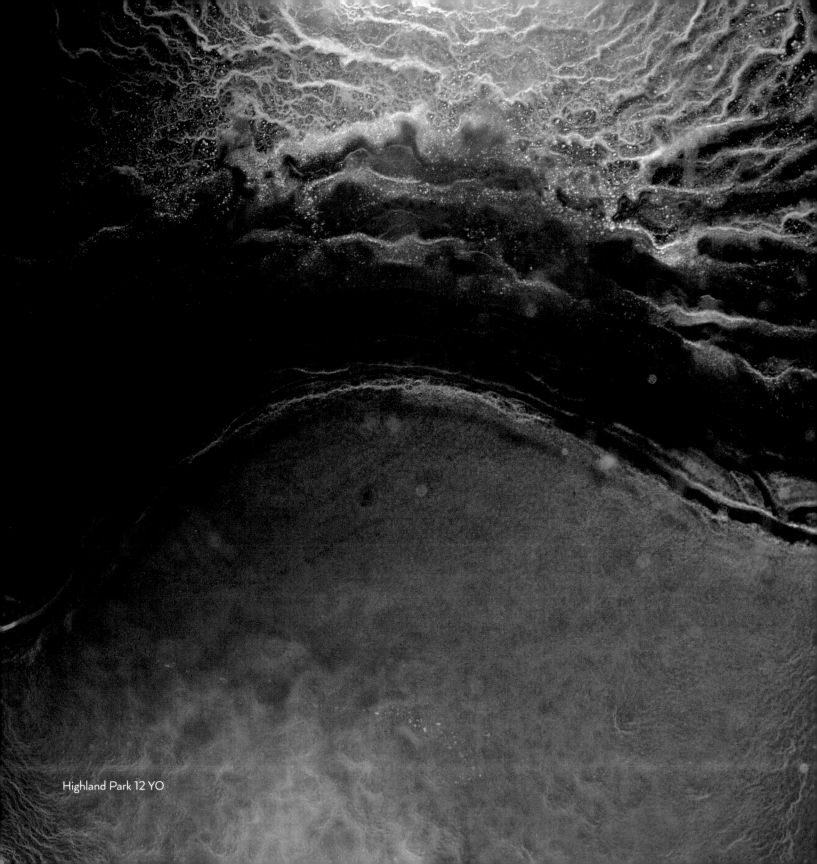

Highland Park 12 YO

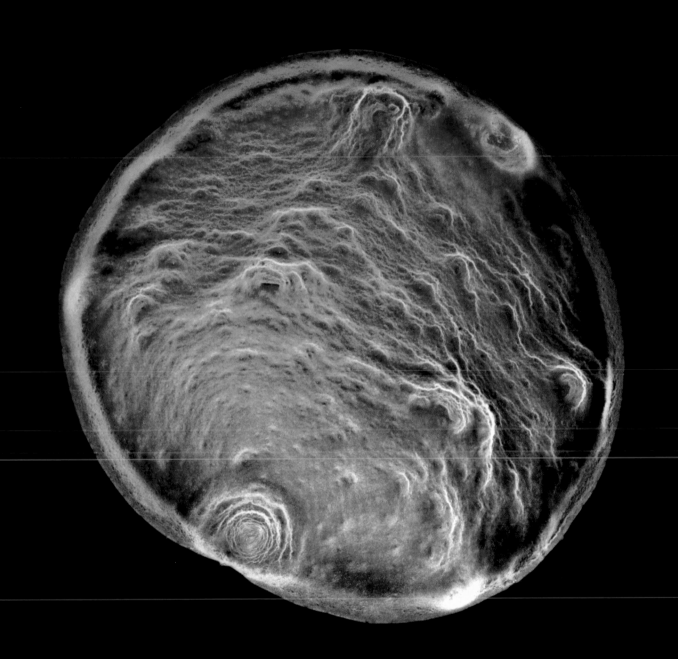

Glengoyne

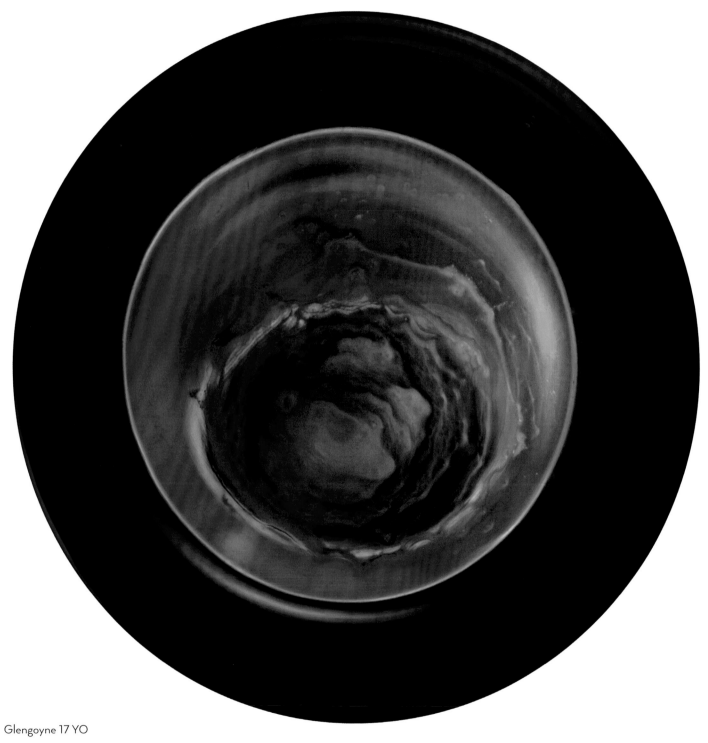

Glengoyne 17 YO

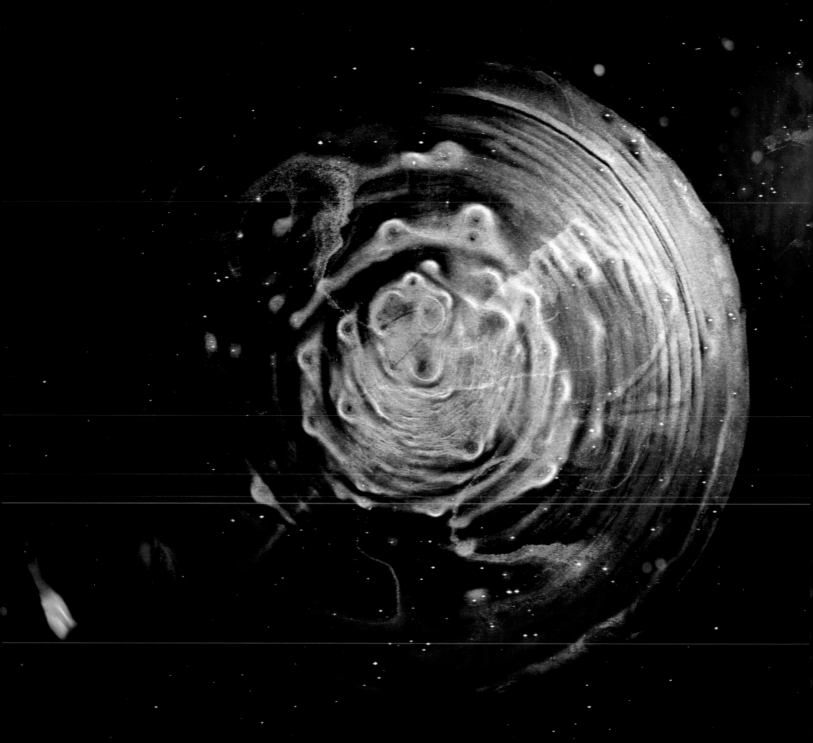

Glenmorangie

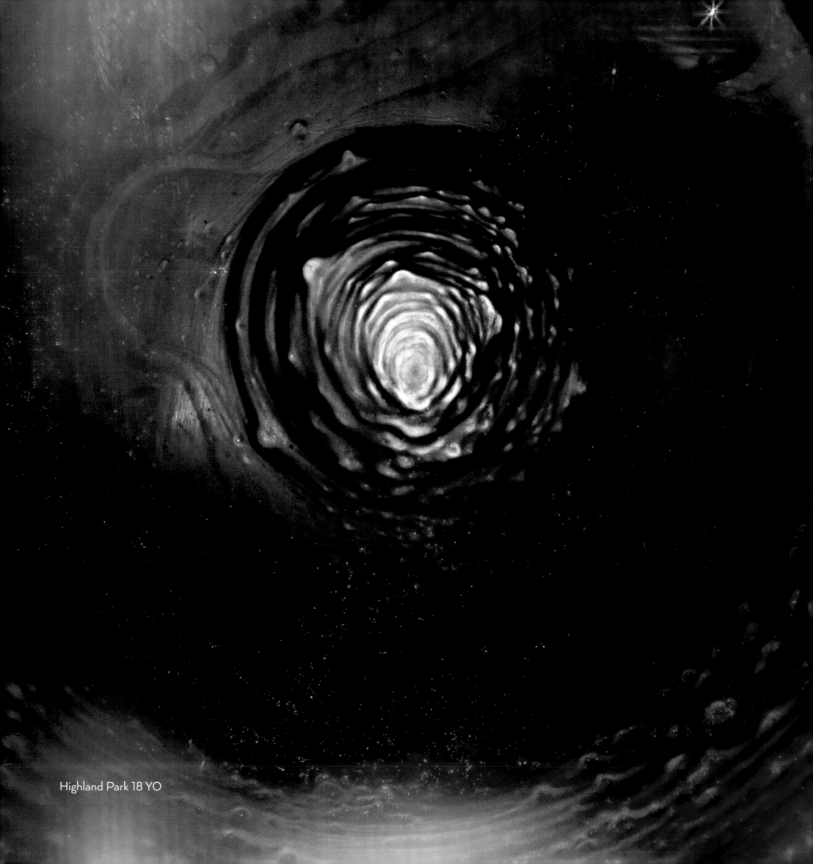

Highland Park 18 YO

## TASTING NOTES

**COLOR:** Clear, bright, burnished gold.

**FLAVOR:** Cherries, dark chocolate, toffee, marzipan, heather honey, aromatic peat smoke.

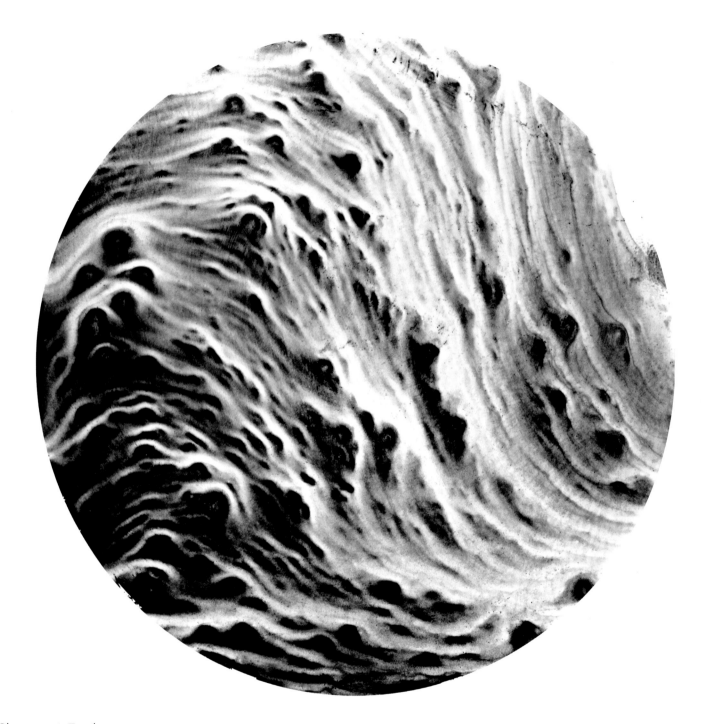

Glenmorangie Tusail

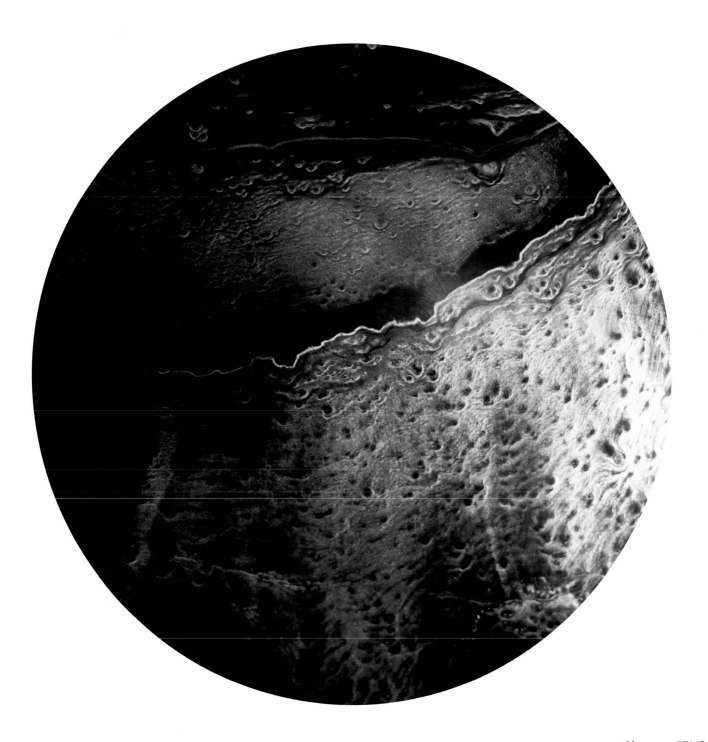

Glengoyne 17 YO

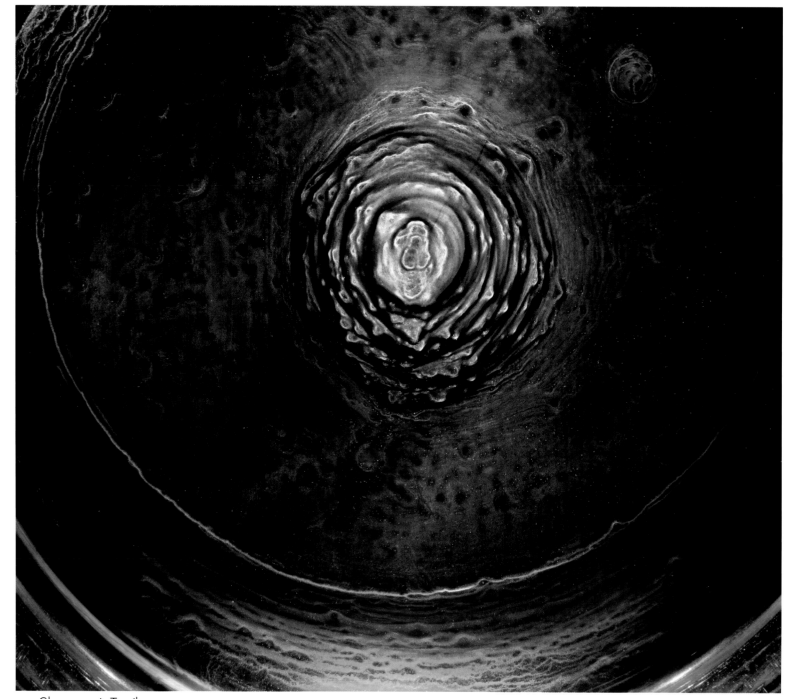

Glenmorangie Tusail

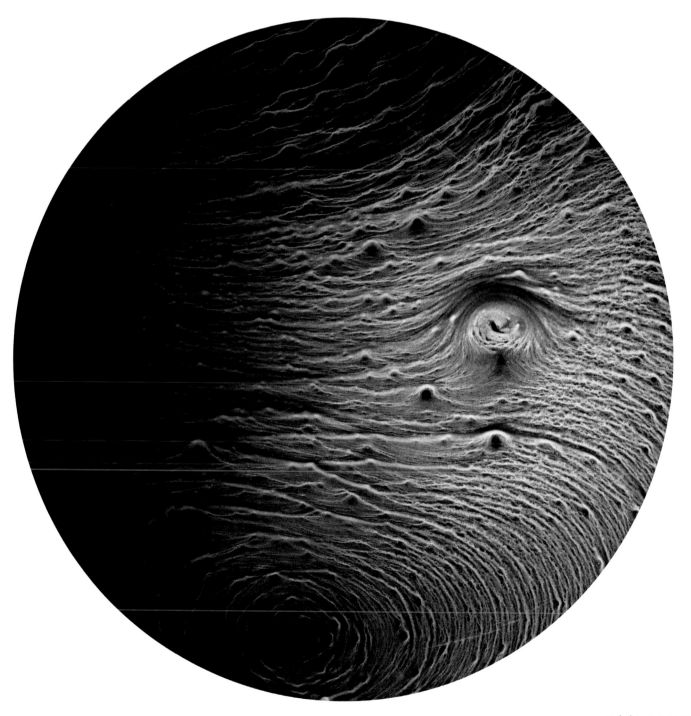

Dalwhinnie 15 YO

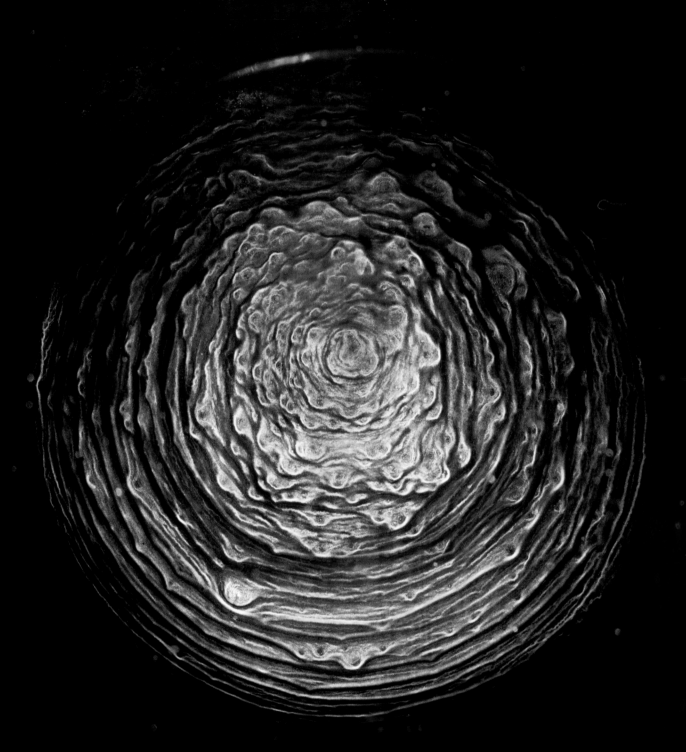

Glengoyne

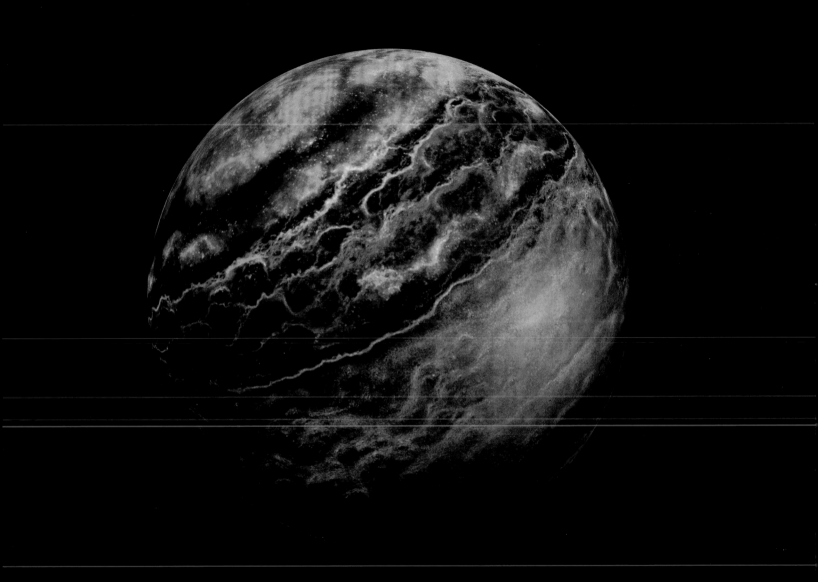

Planet Glenmorangie Sonnalta

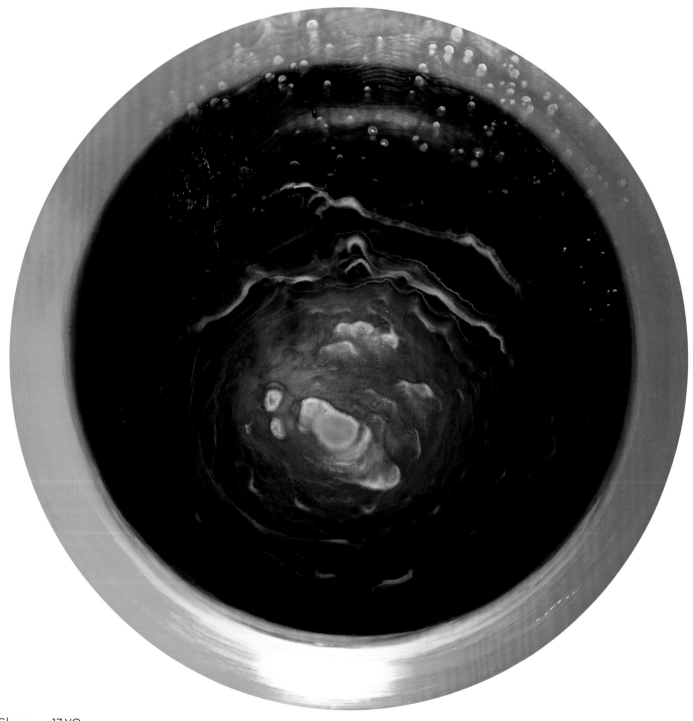

Glengoyne 17 YO

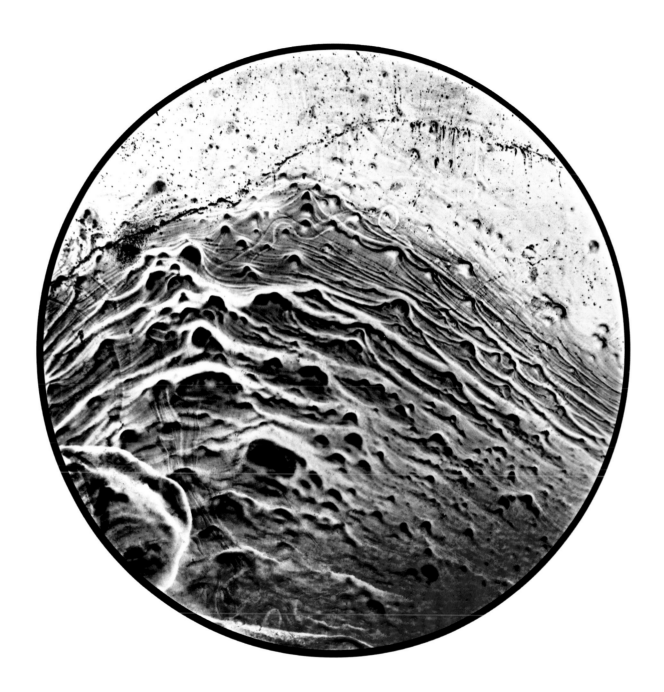

Glenmorangie Signet

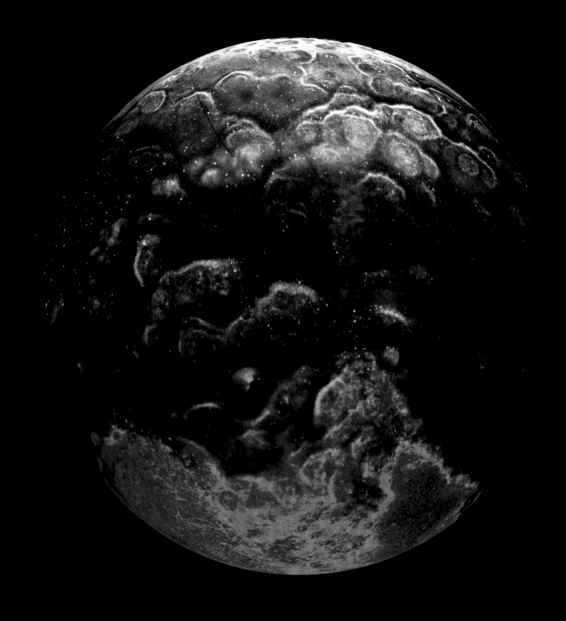

Planet Signet

# TASTING NOTES

**AROMA:** Coffee, ginger, and cinnamon melt into dark chocolate and tiramisu, with dark toffee, crystallized orange peel, and rich fruit cake.

**TASTE:** A velvet explosion of crackling spices swirls around bitter mocha and dark chocolate, toasted hazelnuts, and mellow butterscotch.

**FINISH:** Mocha and spice combine with cappuccino and amaretto, before a finale of chocolate-coated raisins and orange.

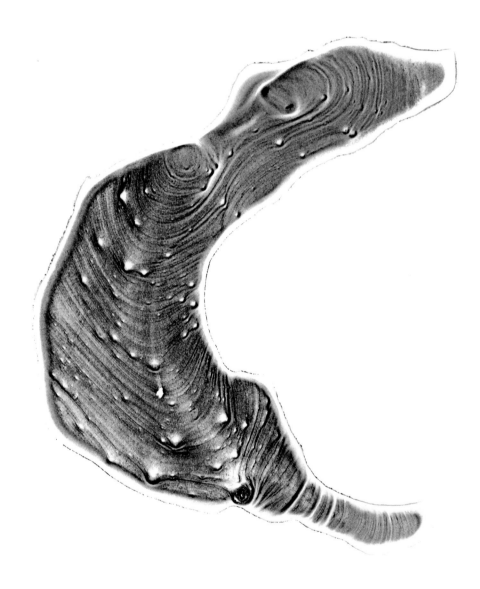
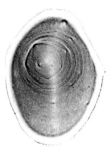

Glen Garioch

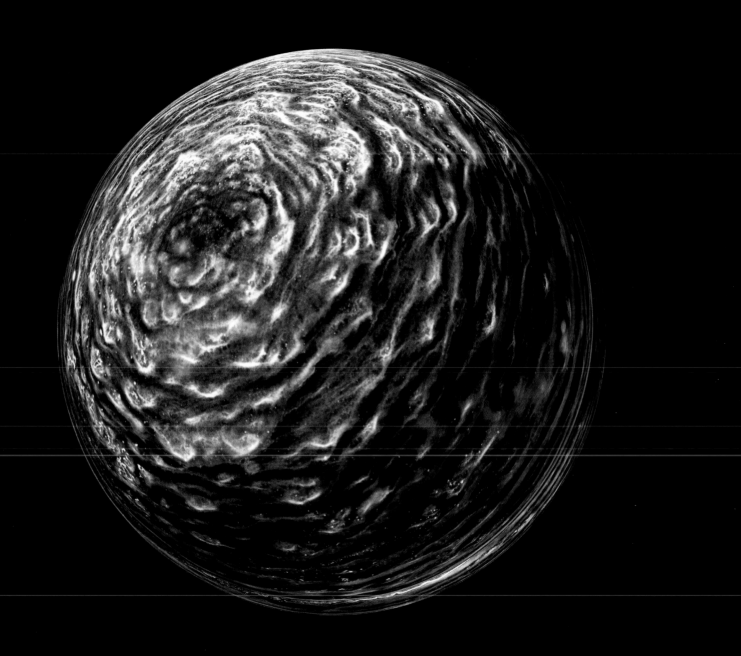

Planet Clynelish

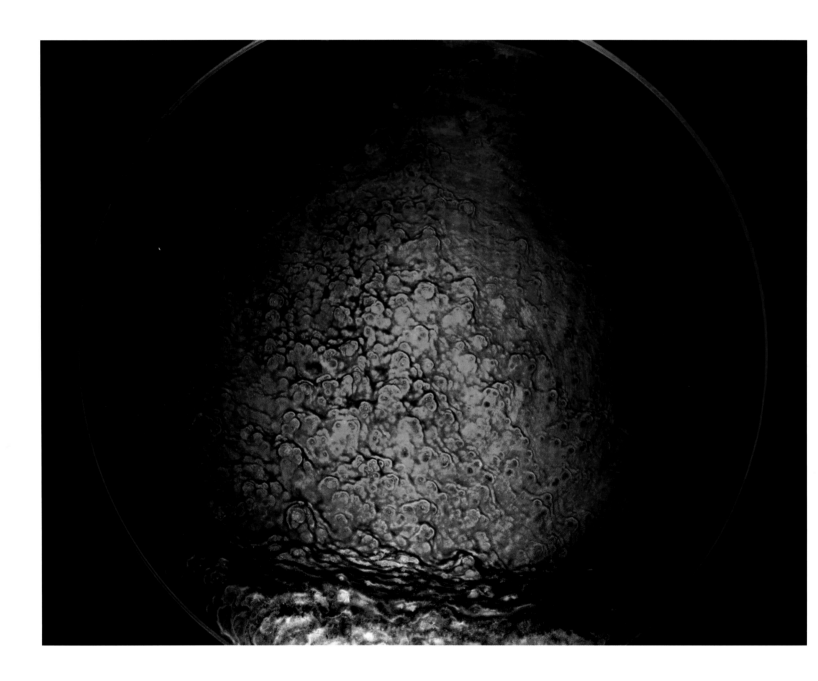

Glenmorangie Signet

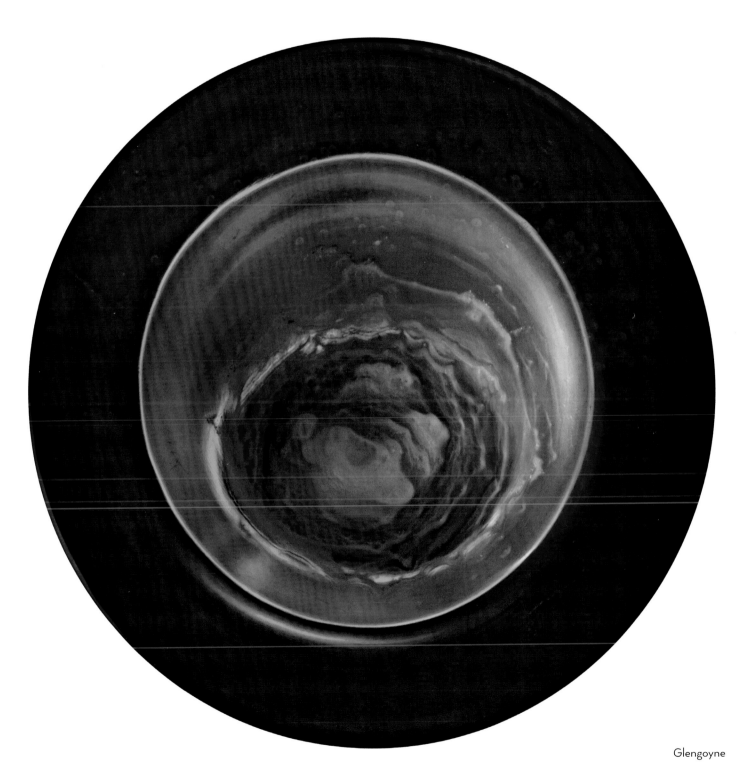

Glengoyne

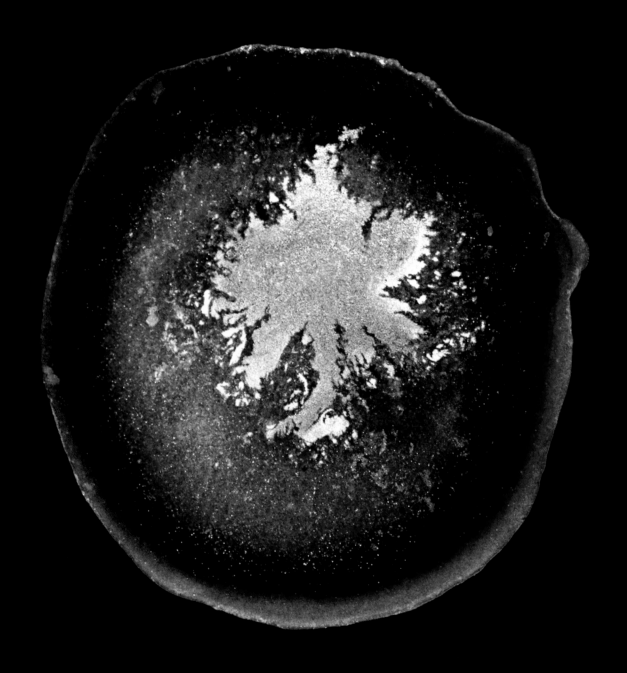

Glenmorangie Tale of Cake

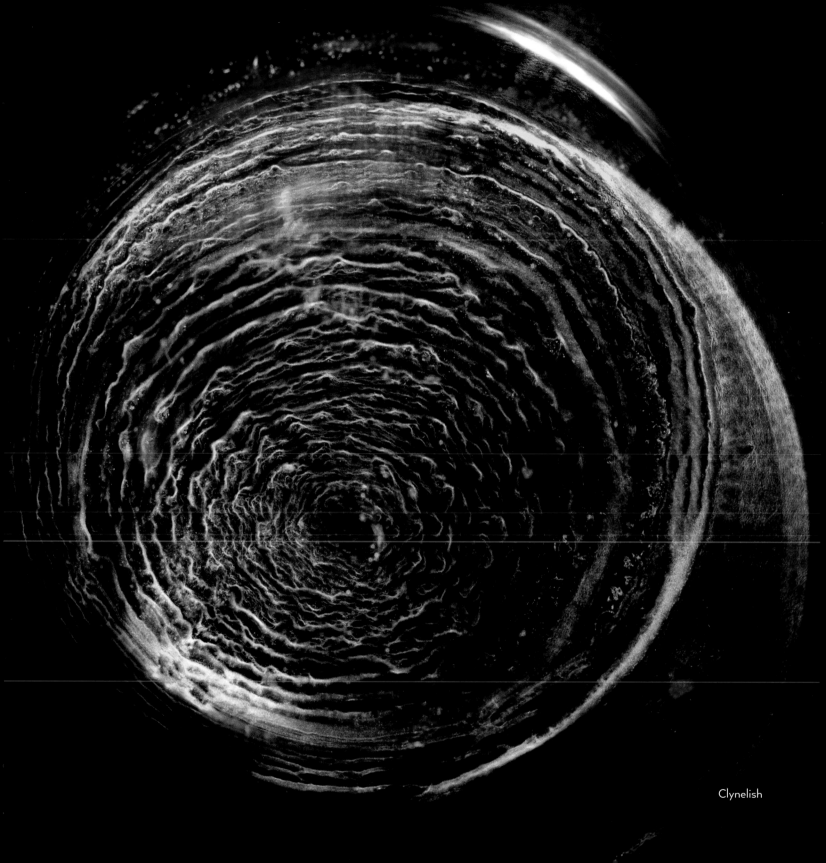

Clynelish

# The Islay Malts

THE ISLAND OF ISLAY IS THE SOUTHERNMOST OF THE HEBRIDES, the chain of islands that stretches down the west coast of Scotland. It is home to no fewer than 10 distilleries (soon to be 11) producing some of the most popular single malts in the world. The island itself has become a place of pilgrimage for whisky lovers.

The Islay malts are typically smoky, in varying degrees, although several distilleries also produce nonpeated variants. They are often described as "elemental."

—C. M.

Ardbeg Seating

Islay Sheep

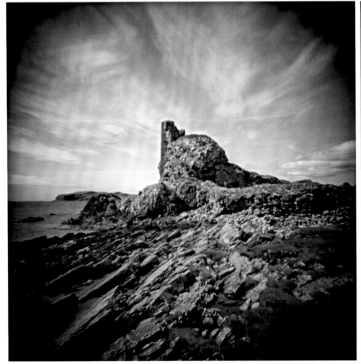

Dunyvaig Castle

Ferry Seating

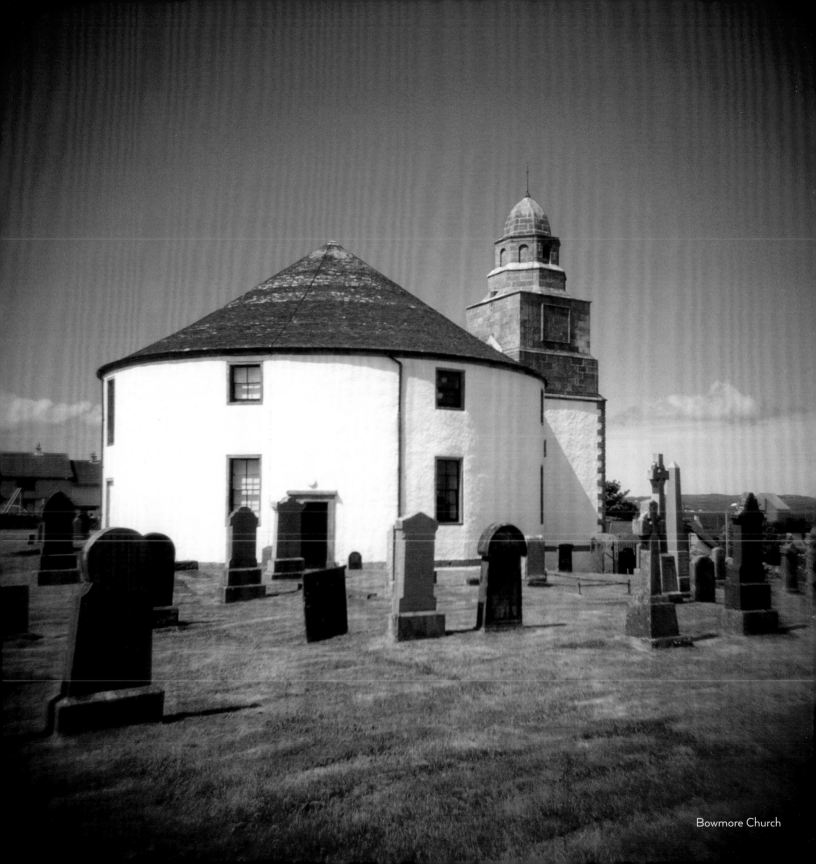

Bowmore Church

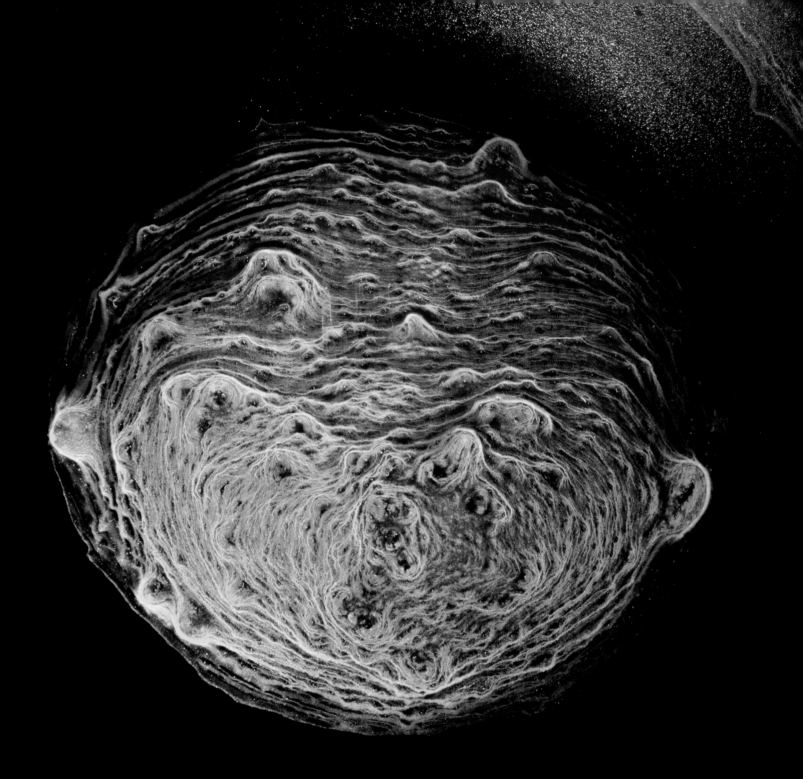

Ardbeg 10 YO

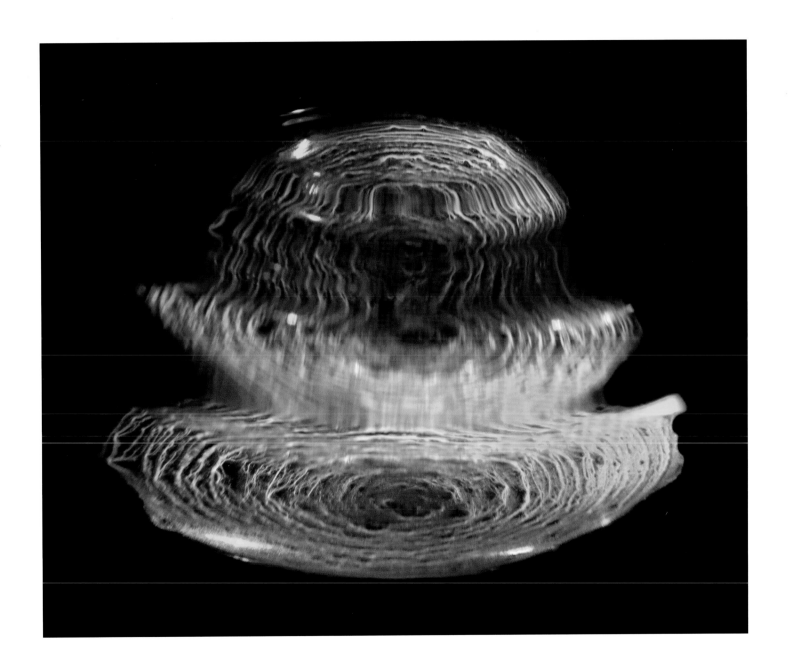

Ardbeg

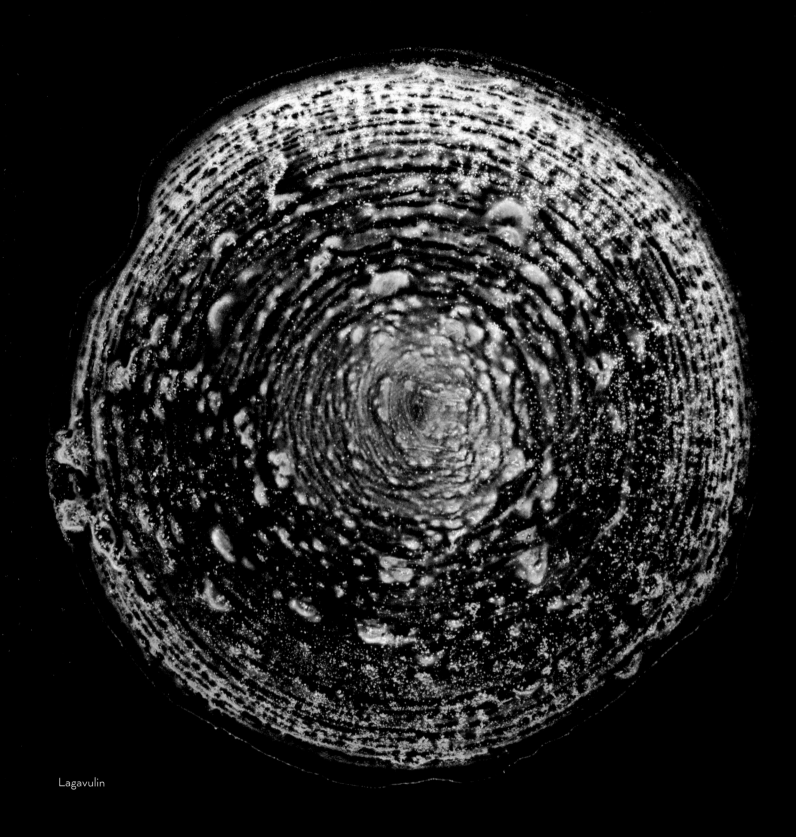

Lagavulin

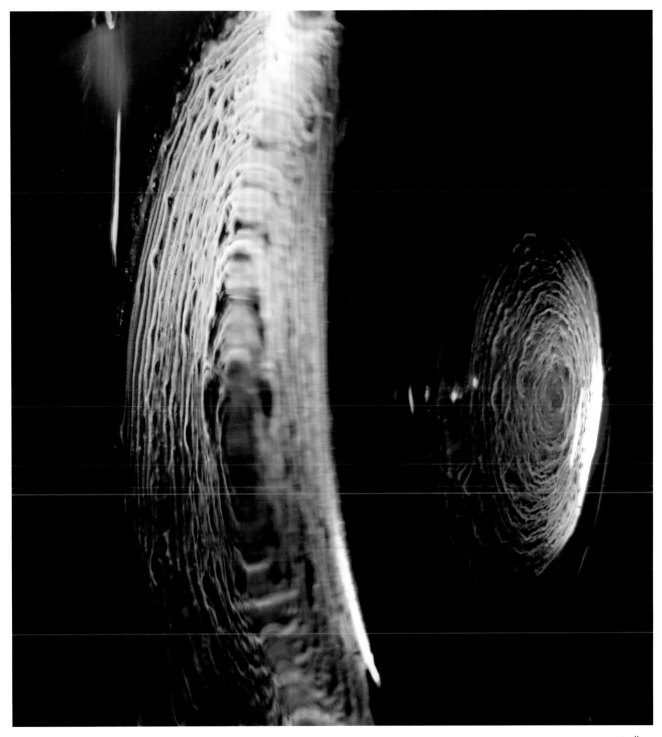

Ardbeg

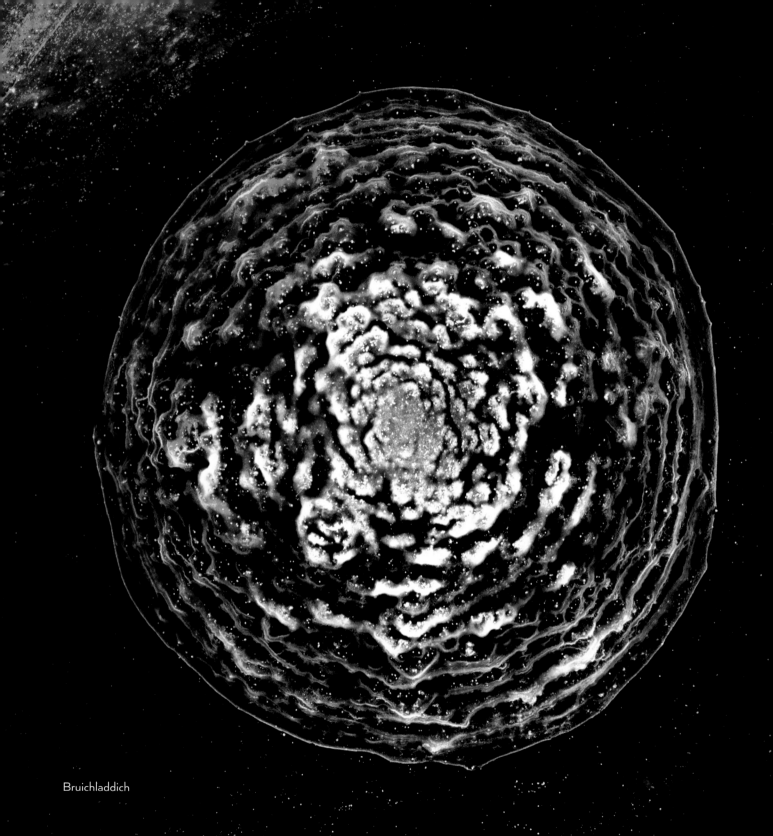

Bruichladdich

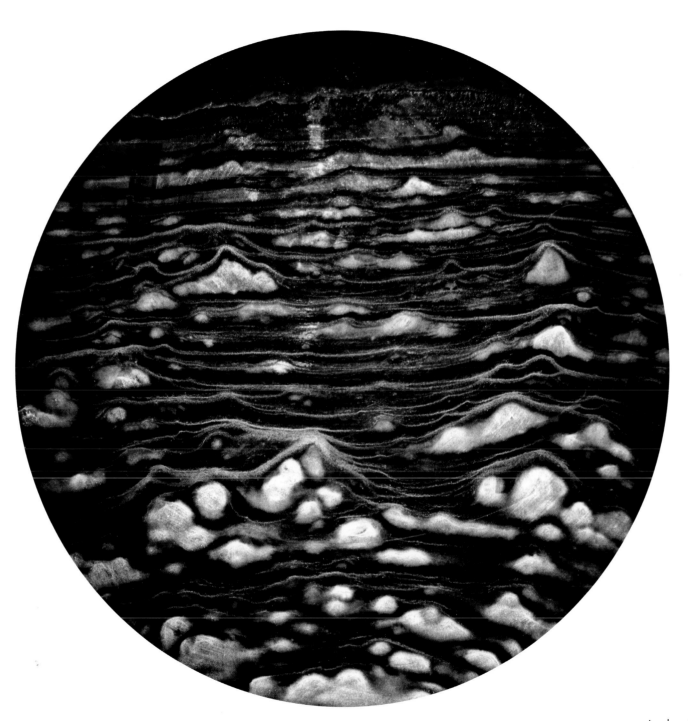

Laphroaig

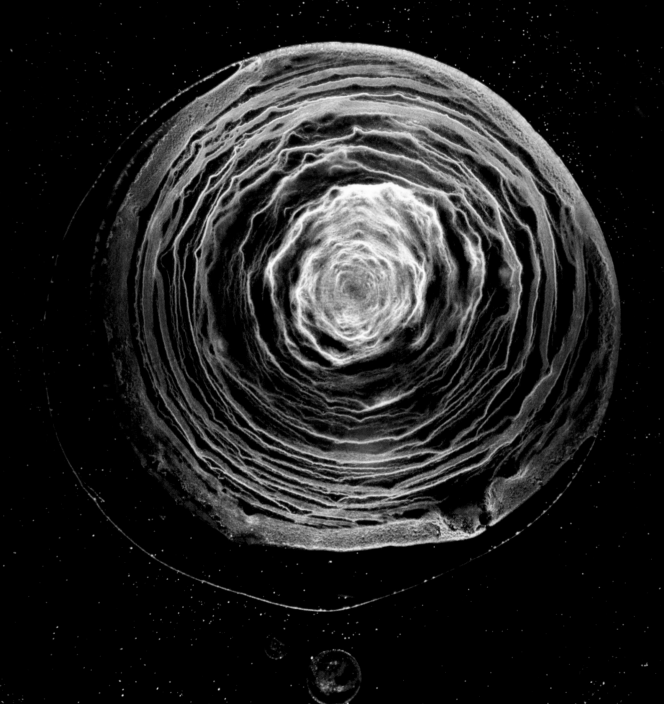

Ardbeg Uigeadail

# TASTING NOTES

**COLOR:** Deepest gold.

**AROMA:** Rich and weighty with heady and smoky aromatics. At full strength, the initial aroma is a beguiling mix of warm Christmas cake, walnut oil, and parma violets fused with fresh ocean spice, and cedar and pine needles falling from the Christmas tree. A smoldering coal fire and the scent of well-oiled leather brings warmth. The sweetness of treacle toffees and chocolate-coated raisins emerge through the smoke. With water, the deep smokiness increases in intensity, reminiscent of a fired Christmas pudding. Rich flowering currants and warm baked banana-and-walnut bread are served with simmering mocha espresso.

**TASTE:** Full flavored and rich with a deep mouth-coating texture, the taste is an intriguing balance between sweet, spicy, and deep smoky flavors. The flavor is initially sweet. A burst of winter spices sets off a smoky-spicy explosion countered by a sumptuous mid-palate of honey-glazed smoked food and chewy treacle. Waves of deep smoky tones and rich aromas build up on the palate like a fine Montecristo cigar.

**FINISH:** Amazingly long and chewy with lingering raisiny, deep mocha tones and rich aromatic smoke into the perfectly integrated finish.

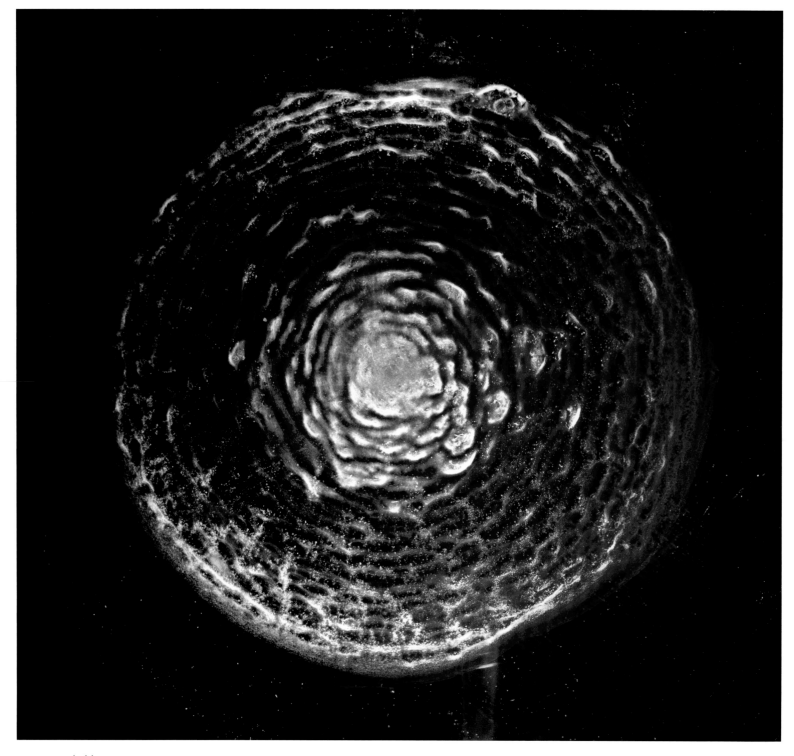

Bunnahabhain

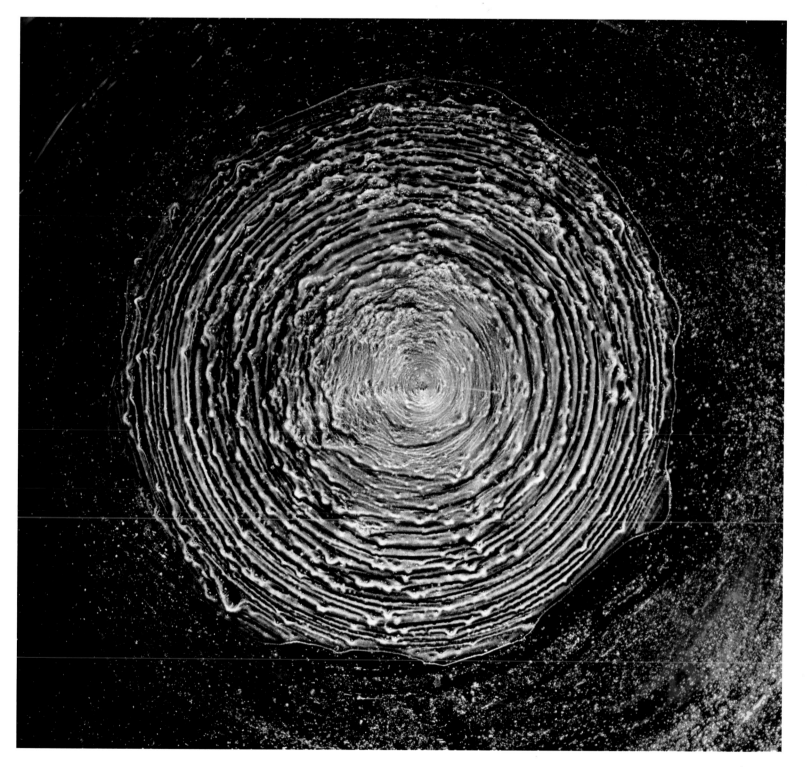

Jura

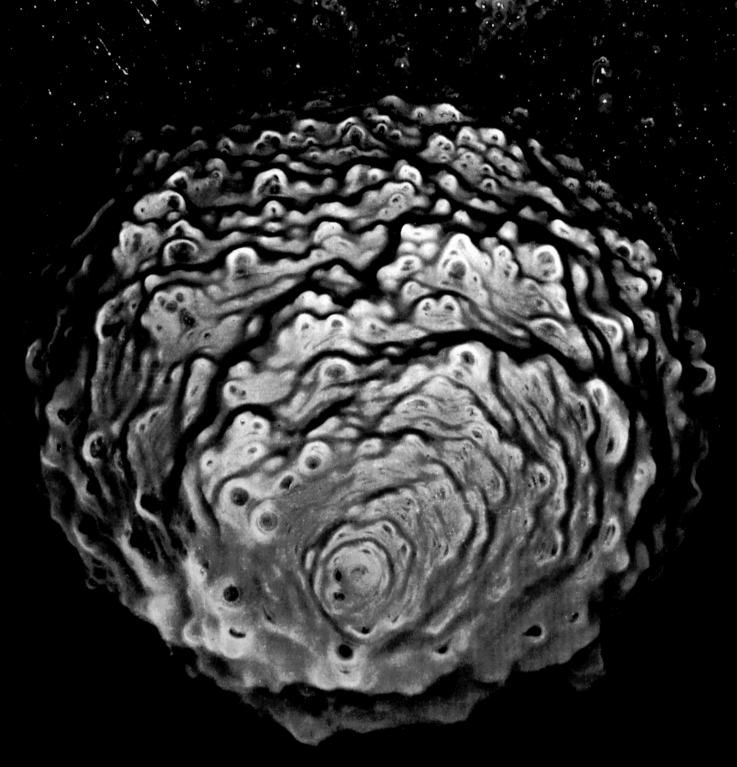

Bruichladdich

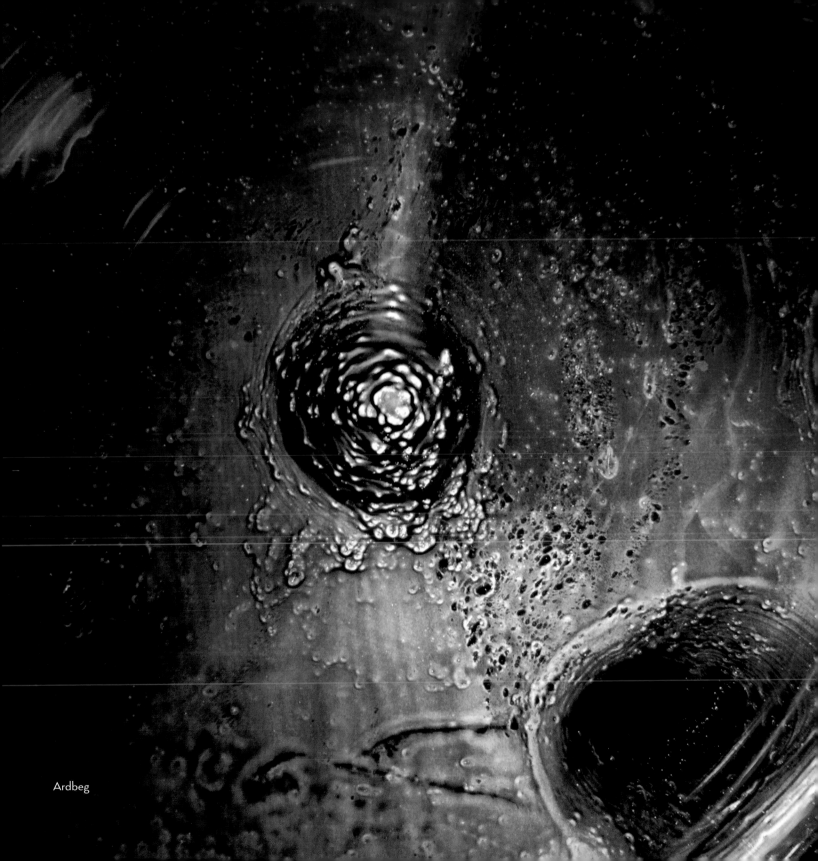

Ardbeg

# CAMPBELTOWN

## The Campbeltown Malts

CAMPBELTOWN IS NOT FAR FROM ISLAY, as the crow flies, and is situated on the long peninsula of Kintyre. Once the distilling capital of Scotland, with 30 distilleries, today it has only three, one of which, Springbank, produces three distinct styles of spirit—heavily peated, lightly peated, and unpeated. The overall style of the Campbeltown malts is maritime and "traditional."

<div align="right">—C. M.</div>

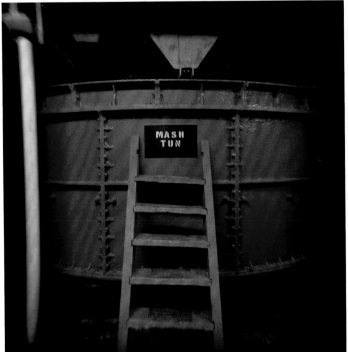

Springbank Mash Tun

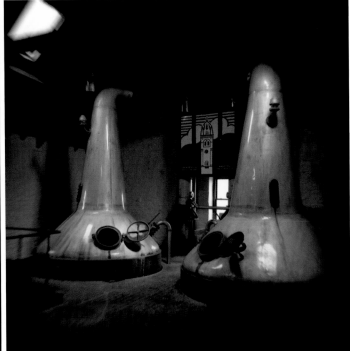

Glengoyne Distillery Stills

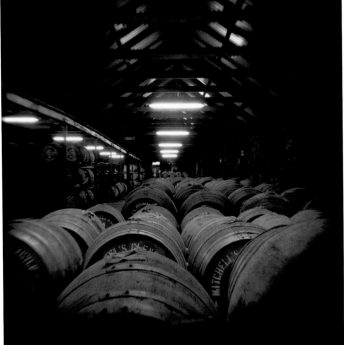

Warehouse of Barrels

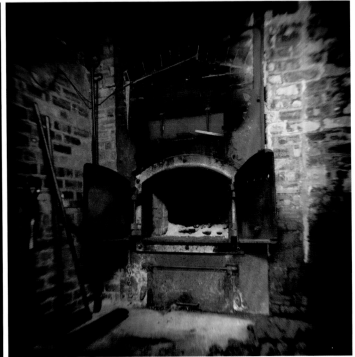

Springbank Distillery Furnace

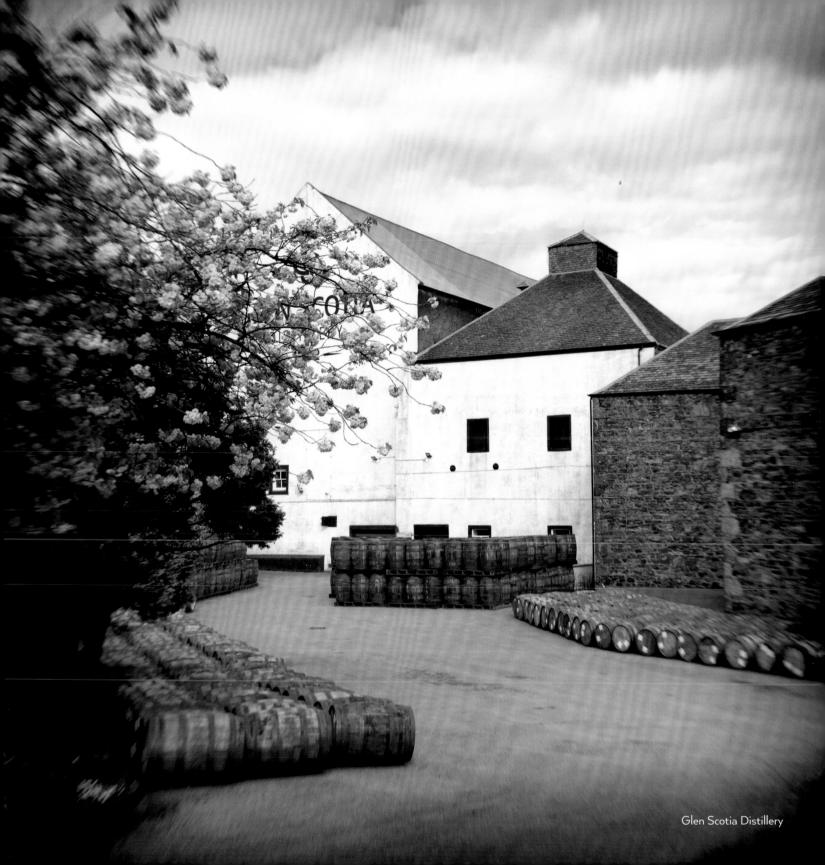

Glen Scotia Distillery

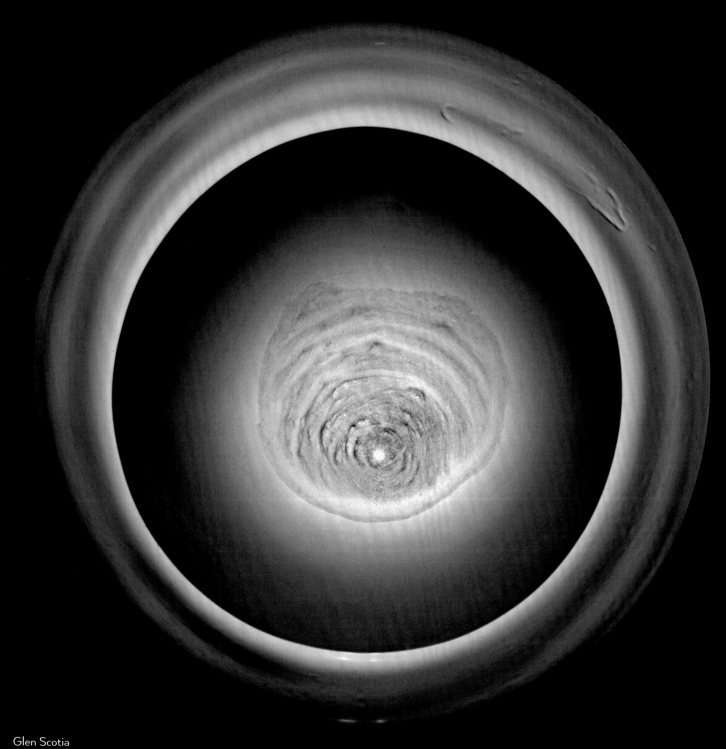

Glen Scotia

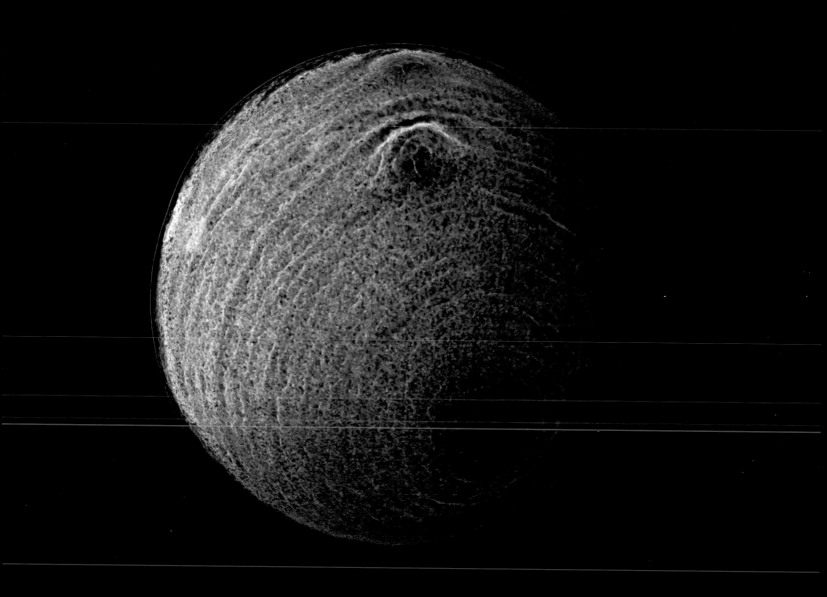

Planet Springbank

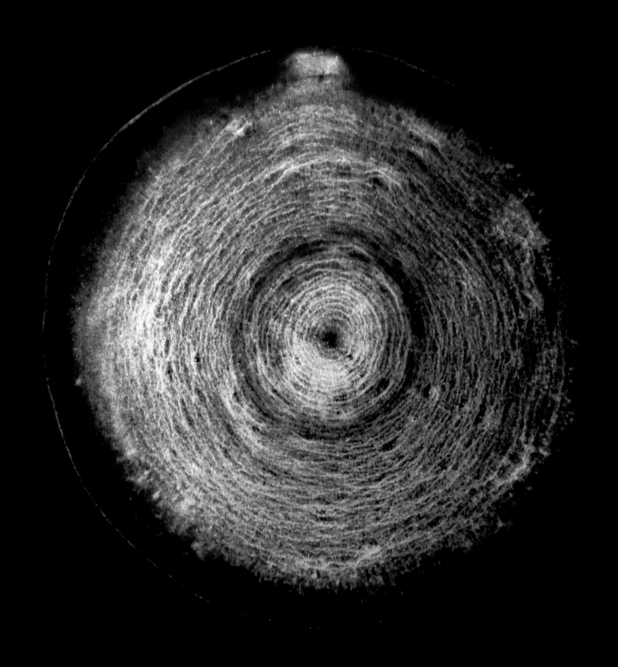

Springbank 10 YO

## TASTING NOTES

**NOSE:** Orchard fruit (pear) with a hint of peat, vanilla, and malt.

**PALATE:** Malt, oak, spice, nutmeg and cinnamon, vanilla essence.

**FINISH:** Sweet with a lingering salty tingle.

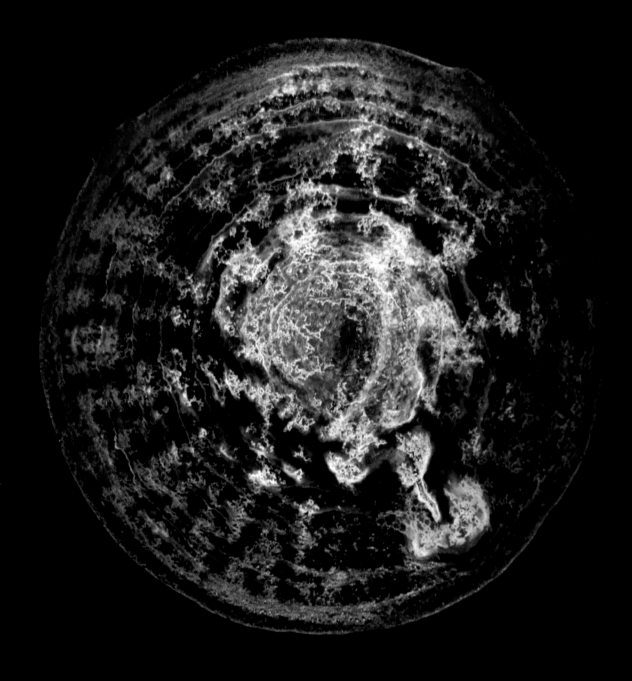

Springbank 10 YO

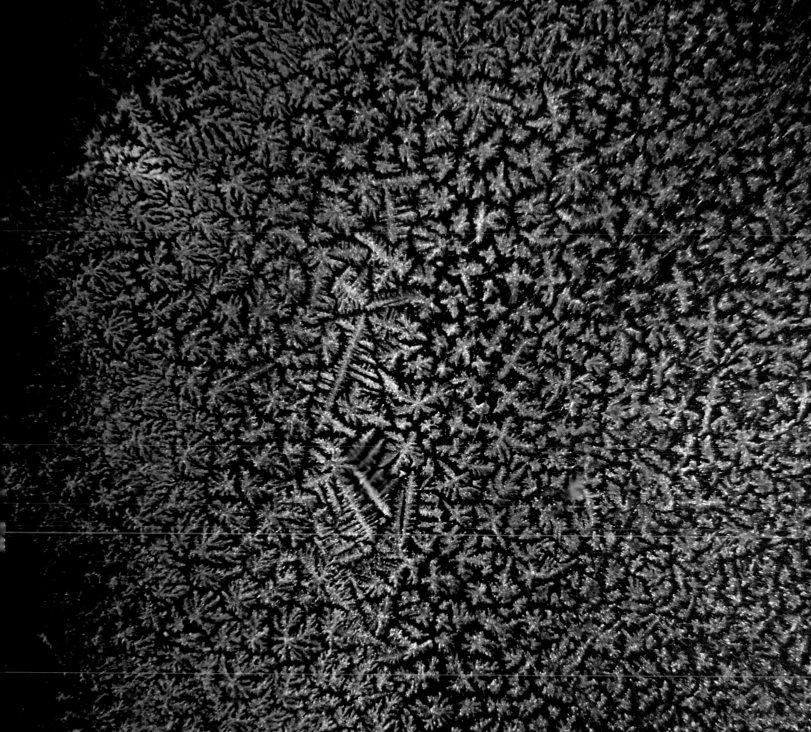

Glen Scotia

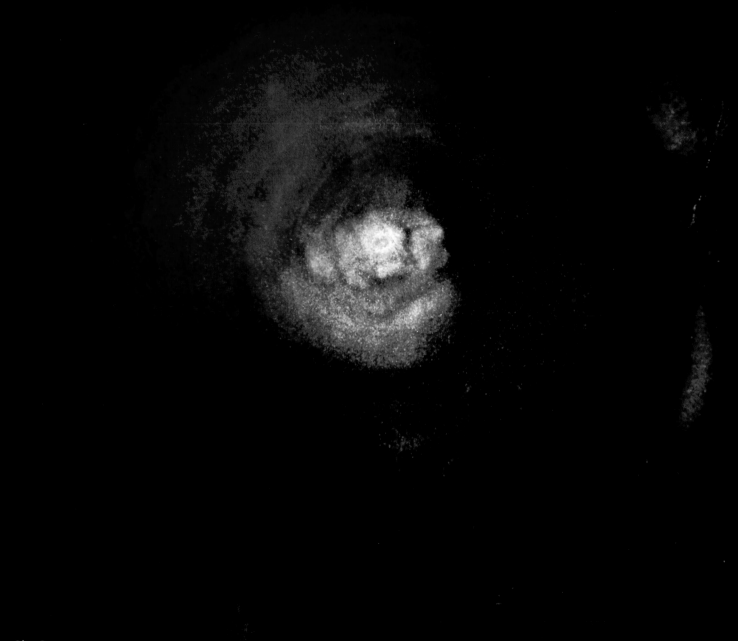

Glen Scotia

OPPOSITE: Glen Scotia

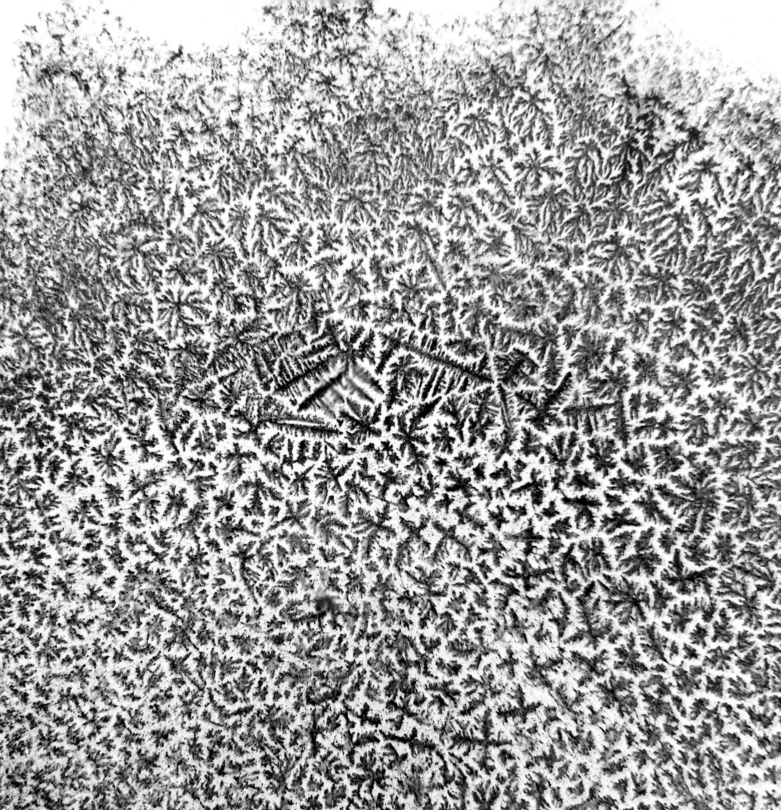

# LOWLAND

# *The Lowland Malts*

THE SCOTTISH LOWLANDS STRETCH FROM THE CENTRAL BELT to the English Border and was the cradle of the Agricultural Revolution in Scotland, its fertile soils making it possible to produce whisky on an industrial scale by the late eighteenth century. Much of this was grain whisky (made from malted and unmalted barley, wheat, and corn), but there were numerous Lowland malt distilleries as well.

The number of distilleries dwindled to only three by the 1980s, but there has been a big revival since 2004, and today there are 22 Lowland malt distilleries.

Lowland malts are generally light in color and body, unpeated, and typically with an overall dryness and a short finish—which makes them excellent aperitifs. They tend to be grassy and herbal, sometimes with citric, floral, or cereal notes.

—C. M.

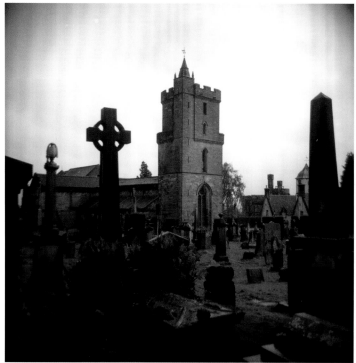

Stirling Castle Graveyard

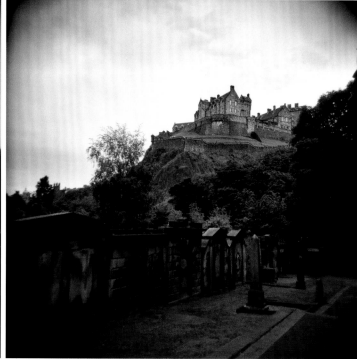

Edinburgh Castle

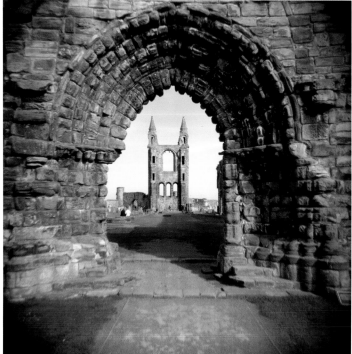

St. Andrews Cathedral

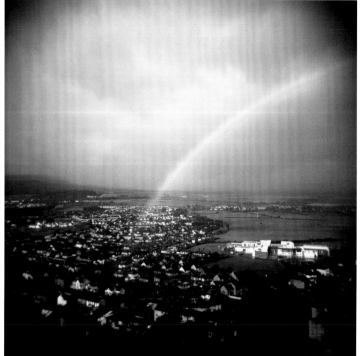

Stirling Rainbow

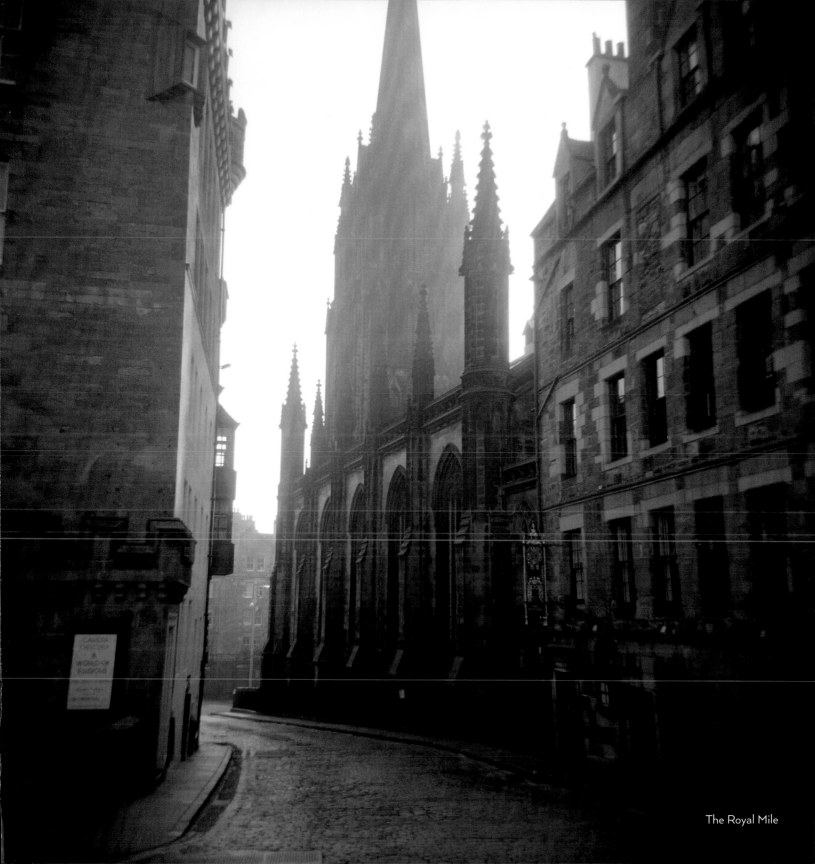

The Royal Mile

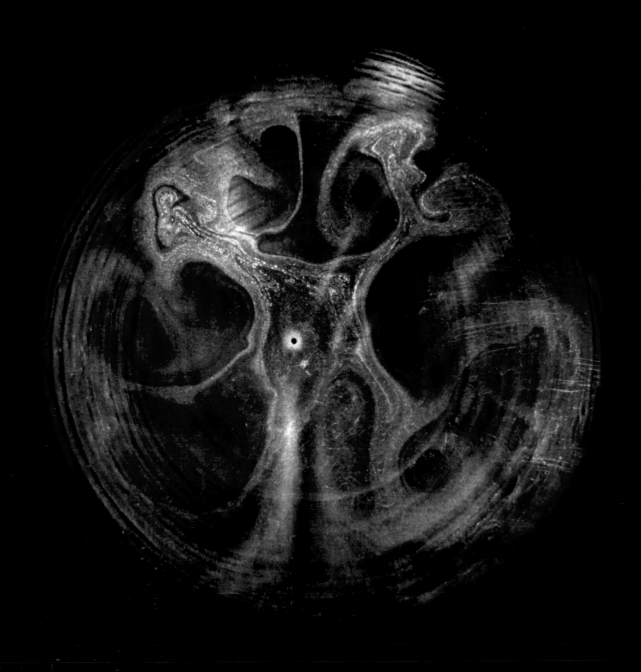

Glenkinchie Distiller's Edition

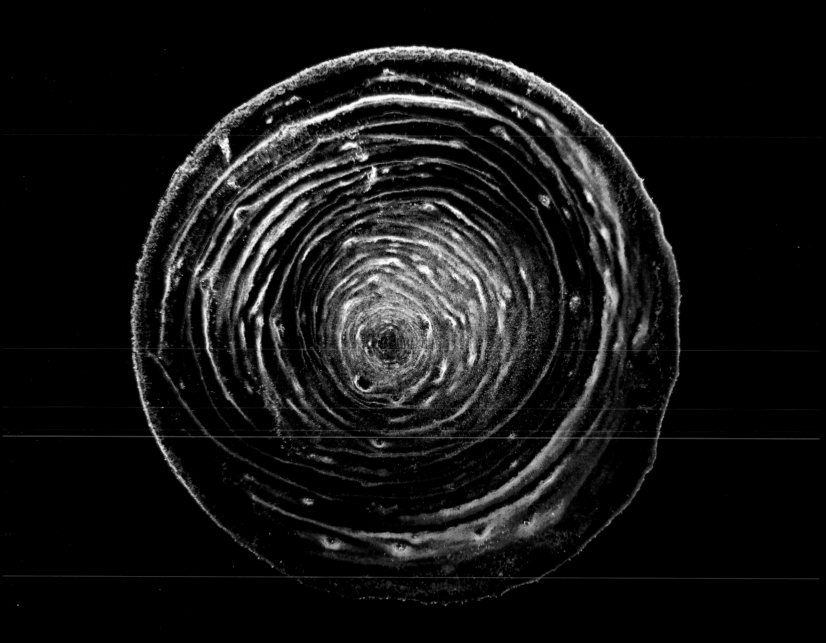

Glenkinchie Distiller's Edition

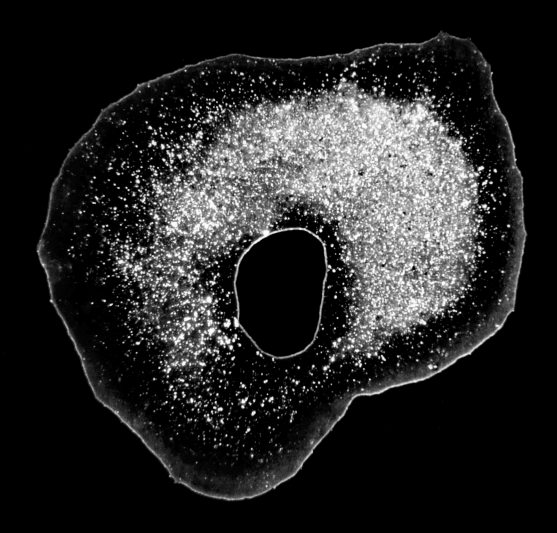

Auchentoshan Three Wood

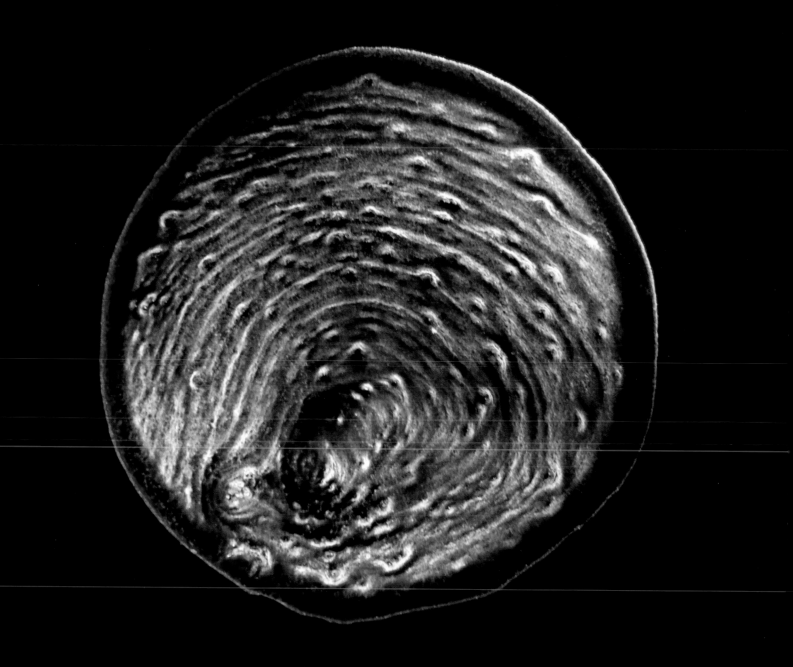

Glenkinchie Distiller's Edition

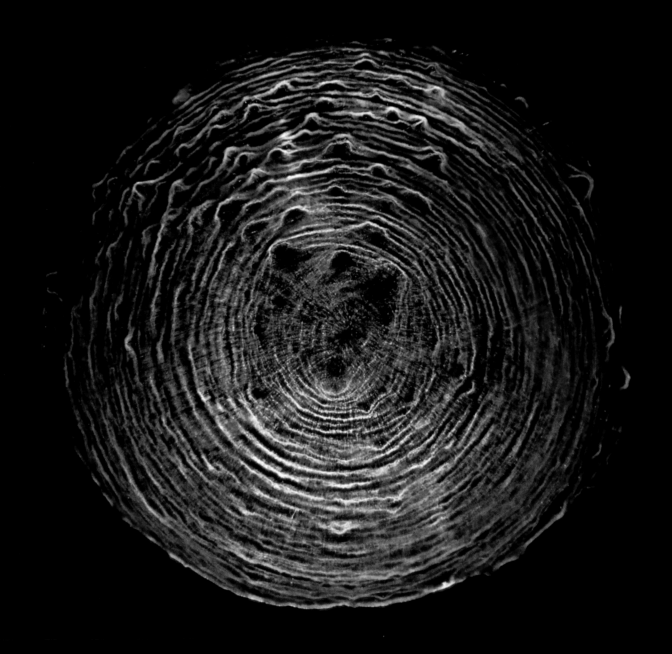

Girvan Distillery (Single Grain)

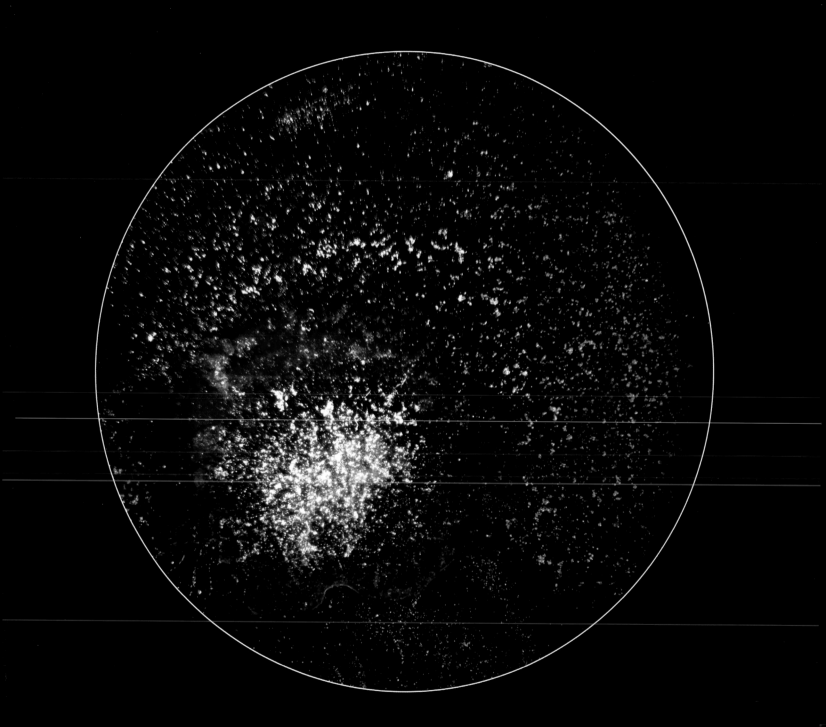

Auchentoshan Three Wood

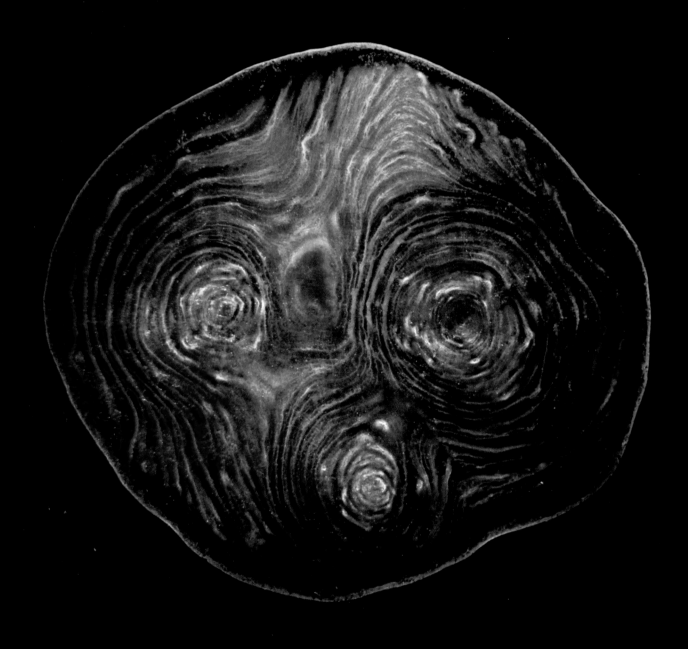

Glenkinchie Distiller's Edition

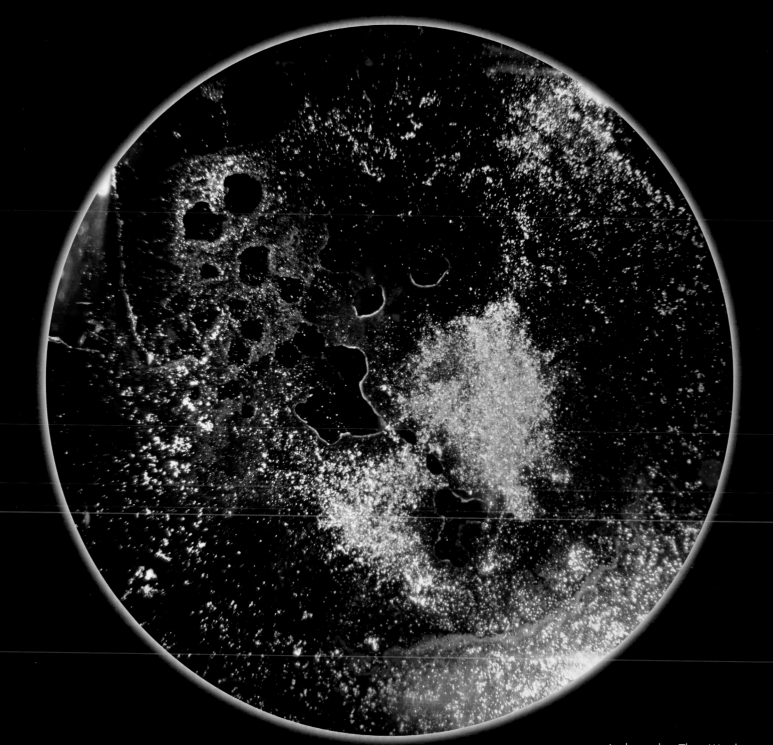

Auchentoshan Three Wood

## ACKNOWLEDGMENTS

I am grateful to the many people that I've met along this journey that have supported this project and encouraged its continued creation:

Howard A. Stone and Hyoungsoo Kim for taking my questions about the formation of these patterns, embracing the science of the project, and pursuing research to help answer them. Brian Kinsman, David Stewart, Gemma Louise Paterson, Andy Fairgrieve, Adele Joyce, Kieron Elliott, Ken Grier, Rachel MacNeill, Charles MacLean, Hans Offringa, Colin Hampden-White, Martin Daraz, Karlsson Banks, John Little, and Glencairn Glasses for the encouragement and support from the whisky industry. A special thank you to Christopher Coates, who was kind enough to allow me to use his scenic images of Campbeltown (featured on pages 154 and 155) when I was not able to visit the region due to COVID-19 lockdowns and travel restrictions. Anne Kelly and the team at Photo-Eye Gallery, Laura Moya, Hamidah Glasgow, Gordon Stettinius, Ann Jastrab, Melanie and Michelle Craven from Tilt Gallery, and Susan Burnstine for their consistent encouragement from the photography world. And a special thank you to Mike DiBiase, as the instigator of this journey discovering Scotch whisky. Scotland is a beautiful country. Ultimately, I look at this project as a love letter to Scotland—its people, its landscape, the whisky, and all that is Scotland. And, most importantly, this book is dedicated to my wonderful wife, Melissa, whose love and assurance have taught me so many things beyond the appreciation of a fine Scotch whisky. This book would not have been possible without you.

## ABOUT THE AUTHOR

Ernie Button is an award-winning photographer based in Phoenix, Arizona, whose work has been exhibited in the United States, China, Scotland, and Europe. His photographs are in permanent collections including the Lishui Photography Museum in China, the Macallan Distillery in Scotland, the Phoenix Children's Hospital in Arizona, and the Southeast Museum of Photography in Florida, as well as in many private collections. His work has also been featured in *National Geographic* magazine, the *New York Times*, *Whisky Advocate*, *American Photo*, *Popular Photography*, *Esquire*, *Wired*, *Smithsonian*, *Whisky Quarterly*, *Popular Mechanics*, *Scientific American*, and on NPR. For more than a decade, he has investigated the dried remains of Scotch whisky through microphotography, and in biannual journeys explored the beauty of Scotland and the creation of Scotch.

## ABOUT THE CONTRIBUTORS

Charles MacLean, MBE, has been writing about whisky for 40 years and has published 17 books on the subject. He has been described by the London *Times* as "Scotland's leading whisky expert." He sits on several judging panels, including that of the International Wine & Spirits Competition (IWSC), the World Whisky Awards, and the Scottish Whisky Awards, and has chaired the nosing panel of the Scotch Malt Whisky Society since 1992. In 2009 he was elected Master of the Quaich, in 2012 he won the IWSC's Outstanding Achievement Award, and in 2016 he was inducted into the Whisky Hall of Fame. He lives in Edinburgh, Scotland.

Howard A. Stone is the Donald R. Dixon '69 and Elizabeth W. Dixon Professor in Mechanical and Aerospace Engineering at Princeton University. He was the first recipient of the G. K. Batchelor Prize in Fluid Dynamics (2008) and was the 2016 recipient of the Fluid Dynamics Prize of the APS. He was elected to the National Academy of Engineering in 2009, the American Academy of Arts and Sciences in 2011, and the National Academy of Sciences in 2014.